D1497448

STRONG DRINK,
STRONG LANGUAGE

Strong Drink, Strong Language

JOHN ESPEY

John Daniel and Company, Publishers
SANTA BARBARA 1990

"Even Comedy Must End" and "Strong Drink" first appeared in *Michigan Quarterly Review*.

Design and typography by Jim Cook/Santa Barbara

LIBRARY OF CONGRESS CATALOGING-IN-PUBLICATION DATA
Espey, John Jenkins, 1913-
 Strong drink, strong language / John Espey.
 p. cm.
 ISBN 0-936784-80-6:
 1. Espey, John Jenkins, 1913- —Biography—Youth.
2. Authors, American—20th century—Biography—Youth.
3. Shanghai (China)—Social life and customs. I. Title.
PS3509.S537Z475 1990 90-2791
818'.5403—dc20 CIP
[B]

Published by John Daniel and Company, Publishers
Post Office Box 21922, Santa Barbara, California 93121

Distributed by National Book Network
4720 Boston Way, Lanham, Maryland 20706

For Mary Frances
My Sister Superior

Strong Drink, Strong Language

Matters of Balance

ONE OF OUR MOTHER'S PREOC-cupations during the years that my sister, three years my elder, and I were growing up in China was preparing us for our college days in America, when we would have to get along on our own. She enjoyed greater success with my sister than with me, especially in financial matters. Money always burned a hole in my pocket, and Mother's first attempt to teach me the values of saving and budgeting had backfired. Not only that, they had backfired in America, when, at the age of nine, I spent a winter in Des Moines with Mother and my sister, leaving Father in Shanghai until his furlough came

due the next year. Mother had insisted that both my sister
and I needed our teeth straightened, and since no orthodon-
tist practiced in Shanghai, we had come to America a year
earlier than normal. So long as we tithed to the church, our
generous allowances were our own to spend, and spend mine
I did, almost exclusively on Hershey bars and Eskimo Pies.
Mother didn't approve of this, I knew, but she said nothing
for some time, and when she finally took action she started
obliquely.

She pointed out that the satisfactions I got were passing
ones. After I'd eaten a Hershey bar I had probably done my
teeth no good and I had nothing left to show for my money. I
agreed, saying that I still felt it was worth it just to have the
pleasure of those moments.

Mother said she understood, but she wondered if I'd
thought of the advantages of spending my money on some-
thing that I not only wanted and could enjoy but could be
used over and over again.

I suspect now that she had seen me stop more than once
before a window display in the hardware shop I passed on my
way to and from school. It included a magnificent Boy Scouts
of America pocketknife, bristling with blades and special
tools, and adorned with the B.S.A. insignia. I had priced it
once, but it commanded a sum so far out of my weekly range
that I gave up on it immediately. However, just to show
Mother the hopelessness of this, I mentioned the knife.

"Do you know how much it would cost?"

I named the unattainable sum.

She must have priced it herself, because with a minimum
of mental calculations she came back almost immediately
with, "If you saved all but your tithe from your allowance

and treated yourself to just one candy bar on Saturdays you could buy that knife in two and a half months."

"Really?" I asked.

"Really," she repeated, and demonstrated with pencil and paper.

I was well caught. Each week I gave Mother most of my allowance, which she put in an envelope labeled "Scout Knife Fund." Every Saturday I ate a Hershey bar or an Eskimo Pie, and on Sunday I dropped my tithe into the collection plate. From time to time Mother would commend me on the soundness of my plan, and I found myself beginning to think of it as really my own. To reinforce this, Mother would say something like, "It's just a matter of balancing things, you know, of setting what you want in the long run against what you want immediately. And when you are back here in America on your own you will have learned how to manage, how to be independent. As I've said, it's just a matter of balance."

"Yes, Mother," I would say, emptying the envelope and counting my growing savings.

At last the Saturday came when I could go into the hardware shop and claim my knife. I bore it off in triumph, though not forgetting to stop at the corner drug store for a Hershey bar that I ate with special satisfaction on my way home.

"Now you have something that will serve you all the rest of your life," Mother said, "not to mention cutting down on your dental bills." I could only agree.

In church the next day I reached into my right-hand pocket for my tithe. It wasn't there, nor was my new Scout knife, which I'd brought along to comfort me during the sermon.

I tried the other pocket to make sure, and then slid my hand back into the right-hand pocket. It held only my handkerchief, and beside the handkerchief I felt the hole that the heavy knife had made in the thin cloth.

I knew I could say nothing in church. When the collection plate was passed I handed it on to my sister without pause. Mother looked puzzled but said nothing. I could hardly wait for the Benediction.

"What are you in such a rush for?" Mother asked as I jumped up.

"My knife!" I said. "My new knife. It's made a hole in my pocket and slipped out. It's gone!"

"Gone?"

"Gone," I repeated. "You'll excuse me if I don't wait."

I don't know how many times I covered and re-covered the blocks between the church and our house before I accepted the fact that my beautiful Scout knife was gone for good. Back home, I tried to figure out how many Hershey bars and Eskimo Pies I had passed up to own a heavy Scout knife for just about twenty-four hours.

I didn't blame anyone. I just wandered silently through the house looking martyred.

Mother told me I had been careless, which increased my look of martyrdom if that was possible. She may have toyed with the idea of buying me a new knife herself, but that would have wrecked the entire lesson. Instead, she offered to advance me enough money for another knife and allow me to repay her by the week, free of interest. That way I would have a knife and still be saving.

I thought this over carefully before I said, "No thank you, Mother. Right now I think I'll try to forget."

She said nothing, and for weeks I squandered my cash on candy.

By the time I was in high school back in Shanghai, my allowance had increased substantially, and Mother's plans now included the handling of my entire clothing allowance. Like many others, I'm sure, I learned the hard way. I spent most of my sophomore year wearing out a pair of ghastly pointed yellow oxfords.

But by this time I was willing once again to save for something, especially when I understood that the only way I was going to get a bicycle was to buy one with my own money. I tried the more obvious ploys of pointing out that all my friends who rode bikes had received them as gifts from their parents, and that I hated to think that I belonged to a family so poor that it couldn't afford this sort of generosity. Neither Mother nor Father understood a word of what I was saying. I even stooped to telling our Chinese-speaking servants about my problem, suggesting that they might talk to Mother about the humiliation they felt in belonging to a household whose only son had no bicycle of his own, and that the cook might casually say to Father that he thought I was of an age now to enjoy bicycle riding.

Mother must have reached them ahead of me. The amah observed that I had had a sickly childhood, that it seemed almost too direct a challenge to the gods to expose myself on a vehicle as precarious as a bicycle, and that she understood the cobblestone streets of the Native City, which we lived just outside of by the old South Gate, made bicycle riding triply dangerous. The cook, her husband, agreed with this and added that so far as he was concerned, bicycle riding was not a dignified form of locomotion. It forced the rider to do

his own work instead of allowing others to do it for him. In fact, he seemed to suggest that by riding a bicycle I would actually be taking the rice out of the mouths of all the rickshaw men in Shanghai.

In the face of my protests he went on to say that so far as being a member of the household was concerned, he wasn't sure that he wouldn't lose a little face personally if it were known among his friends, and particularly back in his home village, that he served a family whose only son got dusty and sweaty pedaling himself through the streets of the city.

"We might as well stop this," I said, and took a swig of strong tea from the spout of the teapot kept filled on the square kitchen table. "I suppose you've heard all about it anyway."

They protested, and we went into a familiar game in which I had to pretend that I believed that after being members of the household for years and hearing English spoken every day, they still couldn't understand a word of that barbaric language.

I knew then that there was no hope for it. Owning a bicycle was to be part of my preparation for independent life in America, and if I was to get one I would have to start saving seriously.

The countermovement opened when not only Mother and Father but also the cook and the amah began dropping hints about setting one's sights too high. They all, it seemed, thought it foolish for me to buy a new bicycle. At least for learning to ride and finding out how useful it would be to own one, and whether I would actually want to ride all the way to South Gate and back from the Shanghai American School over on Avenue Pétain in Frenchtown, where I was a

boarder with weekend privileges, a trip that would include the smoother pavement of the French Concession plus a rough cobblestone stretch from West Gate to South Gate— well, for all this, the sensible thing would be to buy a second-hand bicycle.

I wallowed in martyrdom. If anyone thought it suitable for me to appear in public riding a machine of which I was obviously not the first owner, then the least anyone could do to further this public humiliation was to furnish me immediately with a second-hand bike. I couldn't imagine lowering myself to buy such a thing on my own.

When this eloquence fell on deaf ears I knew I had exhausted all possibilities. I had also painted myself nicely into a corner; for when I priced new bicycles, I found that even Japanese models cost a good bit more than I had imagined.

I began pinching on a number of expenses, including the collection plate at church, without feeling guilt. I cut down on the number of French pastries I bought each afternoon with my good friend Georges Widler, whose father, a prosperous Swiss businessman, would have given Georges a bicycle or anything else he wanted, as Georges pointed out to me. I didn't hesitate to accept an extra pastry or two from Georges after this, just to show my generous spirit. I cut down on the number of movies I went to and grew careful in every way with my allowance.

The day came when I had enough to order my Japanese bike, modeled after an English bicycle, with handbrakes and a handsome nickel bell mounted on the right handlebar. On a late Friday afternoon I signed for its delivery and wheeled my new bicycle to our front steps. Shadows already lay long

across the oval driveway that circled the lawn in front of our house and the double house for the single ladies. We had had tea some time before. I lifted my gleaming bike into the front hall and leaned it against the wall by the hat rack. I had no intention of marring the hour by starting to ride so late in the day.

Everyone who passed the machine commented on it. The cook and the amah and their children stroked it. Mother said, "I wonder if those handbrakes are really as good as the standard American coaster brakes."

"All the American bikes were a great deal more expensive than this," I said. "And anyway, most of the bikes around here have handbrakes."

Next morning I sat impatiently through breakfast and Chinese family prayers with the servants. As soon as I was free, I wheeled the bicycle out of the hall, across the front porch and down the steps to the driveway.

I'm not sure now just what I had expected to happen except that I was acutely aware of never in my life having even attempted to ride a bicycle and that I was now alone and without help. I had seen plenty of bicycles being ridden, and most of my friends owned bicycles, but I had always been too shy to ask them to let me try.

Father worked in his study, one window of which opened on the front lawn. I had hoped that he would at least give me a few pointers. One of the standard family stories from his youth had to do with riding a bicycle beside Lake Chautauqua when he was seventeen or eighteen and just beginning to notice women outside his family. He had been rolling along one summer afternoon when he saw ahead of him a very attractive girl standing by the side of the path. It occurred to

him that he could make a preliminary approach if he spoke to her as he rode past and tipped his black-ribboned straw boater.

This may not sound like an enormously exciting exercise, but for a young man of Father's background it held all kinds of implications of sexual directness and social disorder. He admitted that he had grown excited as he thought of this and speeded up out of sheer animal spirits. As he whizzed past the girl, calling out "Good afternoon!" and taking his right hand off the bar to tip his hat, he turned his head and saw her smile and wave to him. He was wondering if he dared circle back and do anything so irregular as introducing himself when he felt a tremendous sensation of pain in his head and thought he was not only going blind but was probably dying. He never quite lost consciousness, he insisted, but when he was moderately clearheaded again he found himself on the ground, gushing blood from having ridden nose on into a tree.

Father always told this story with a mixture of feelings: surprise and admiration of himself for his boldness, but also an acknowledgment of just punishment for vanity and even, perhaps, sin. His boater had been wrecked, and his nose showed a slight crook for the rest of his life.

I thought of this as I started to mount my bicycle from the front steps. Father sat only a few feet away, on the other side of a brick wall, but if he was not going to volunteer his help I was not going to ask for it.

No miracle occurred. I straddled the bike, keeping my right foot on the edge of the front steps, and got my left pedal up high enough to tramp down on. I made a wobbly start, groped wildly for the other pedal, and sprawled in the gravel before my foot had found it.

The house remained silent. As I picked myself up, refusing to look at Father's study window, I turned the bike around and wondered if I'd been wise in wearing an old pair of khaki shorts. My left leg was scratched, though I could see no blood. I had gone into long trousers that year, but they still seemed too sacred, too much a mark of my not easily assumed manhood, to risk in this.

I tried again and again. I began to wonder if there was something seriously wrong with my sense of balance as the morning wore on. I usually fell to the left, so I tried over-correcting to the right and for a time my only success was falling to the right often enough to balance the scratches and bruises on both my legs.

An hour before tiffin, as we called our noon meal, showing the strong British influence on all Shanghai life, I had fallen so many times that I had jammed the left pedal. My bright new bike was as scratched and dusty as I was and my heart was filled with gall. I went to the servants' quarters and got a hammer. The servants were so busy they had no time to notice me.

I took a couple of cracks at the pedal and freed it. The nickel plating showed hammer marks, but I didn't care.

I kept on until the amah appeared at the front door and told me tiffin would be served shortly. I thanked her curtly and went up to my room. In the adjoining bathroom I took a look at myself. Somehow I had scratched my face as well as my arms and legs. I washed thoroughly and changed into long trousers and a clean shirt.

Conversation never quite started during that meal, an unusual circumstance for the days that my parents and I ate as a threesome. We all held opinions on a variety of subjects,

but nothing promising presented itself that Saturday. I ate rapidly and asked to be excused a few minutes after the finger bowls were placed in front of us.

"I hope you'll be able to get a little rest this afternoon, John," Mother said.

"Yes," Father came in. "I know I've discussed the learning process with you. After a start one seems to learn nothing at all, and then after a rest of a day or two one finds oneself capable of real advance."

The "ones" and "oneself" nettled me. "I appreciate your concern," I said as I rose and turned to go, but not before I caught the look my parents exchanged, each of them finding it difficult to suppress laughter. I wasn't myself amused as I stalked out of the room and went upstairs to change.

Straightening up the bike again, I found that I had actually made some progress. I was falling farther and farther away from the front steps. At first this meant simply that I was getting a better thrust on my left pedal and a stronger shove with my right foot. But later I felt the illusion of control. As soon as I did, it left me and there I was on the ground again. Both legs seeped a little blood.

The first time I had used the hammer to free a pedal I had returned it to the tool box. Later, I kept it ready on the front steps. I found it difficult to recognize the machine I was trying to learn to ride as a virtually new bicycle. I knew that part of this was just the dust and grime it had picked up and that it would reassert some of its newness with a good wiping off, but it already bore scars that it would never lose.

I don't know how long it was—other than an eternity— before I found myself getting as far as the first curve of the driveway and taking it and starting the gentle rise up to the

front gate. At least I had always thought of it as gentle. For the present, it loomed like one of the lesser Alps.

And then I had it.

I wobbled around the first curve with just enough momentum to get to the front gate, and after a jerky turn to the left I was coasting downhill at such a perilous pace that I squeezed both handbrakes and almost went over the handlebar. But I recovered, made the next two curves, and started on my second lap. This went better. I even figured out that I should apply the rear brake before the front one. I circled again with greater confidence and at last I felt control. I took a couple of laps after that for the sheer fun of it, and then I coasted to a stop by the front steps, taking my feet off the pedals and catching the bike as my left foot came flat on the ground.

I still couldn't mount without using the front steps, so after a short rest I started on that. I took a couple of spills, but they were nothing to me now and I laughed to myself.

At last I could not only mount but dismount raggedly. I knew I had a long way to go before I could be considered competent, but I knew too that I had learned to ride my bicycle and that I had learned to ride it entirely by myself. I forgave Father for his parental delinquency. I even considered the possibility of his having gone through the same bitter and proud experience and wanting his son to gather whatever lessons of life could be drawn from it.

The house, which had remained strangely lifeless, began to stir. I saw Father pass the window of his study and as he caught sight of me he smiled and waved. I could see Mother behind the glass curtains of the dining-room windows. One of the servants came out around the side of the house on an

errand. Even the double house of the single ladies woke a trifle.

I leaned my bike against the front steps, thinking that the next thing I would have to save for was a kickstand. I took off the pump that came with the bike and gave each tire a little more pressure. Then I went up to my room, and once again looked at myself in the bathroom mirror. I was a mess. I knew it must be almost time for tea, and this time around I cleaned myself up carefully, washing out the cuts and scratches on my legs and hands and arms. I had quite a gash on my left knee, so I bravely poured iodine into it and made a bandage of cotton gauze and adhesive tape. I stepped into a fresh pair of long white duck trousers and a clean white long-sleeved shirt.

At the appointed hour I strolled down casually for tea. Father began talking about the latest psychology text he was reading, and Mother chimed in with her views on the usefulness of studying international history just to irritate him a little. I said, "I've been going through some modern novels lately. Have you read anything by Ellen Glasgow, Mother?"

"Oh, is that what you've been doing?" Mother asked. "I was under the impression that you'd been working on something else."

I suspected that she had read nothing by Ellen Glasgow and I knew I was being teased. It would be useless to try to draw Father in on this kind of thing because he took a dim view of fiction. So I looked at Mother as I said, "I prefer Edith Wharton, I think. I found *Summer* a truly gritty work."

Father looked down his crooked nose. "That's an odd term of praise," he observed.

"I suppose," I said loftily, feeling very modern. "But of course I have been doing something else, speaking of being gritty. I've learned to ride my bicycle."

"I think I did catch sight of you at that this morning," Mother said, and Father came in straightfaced with, "I noticed you out there on occasion."

"I'm not perfect yet," I admitted, "but I can ride around the circle, and with a little more practice I think I could ride to school and back."

"If you keep your bike at school through the week," Mother said, "you'll need a lock. And where would you store it, may I ask?"

"There's a special shed for bikes down at the corner of Avenue Pétain and Route Dufour," I said, wondering how much a lock and chain would come to. My investment grew larger.

As we got up from the table Mother said, "Perhaps you could show us how well you can ride."

"Yes," Father said, "that should be interesting."

"Of course," I said.

Though only the three of us went out the front door, I felt that within the next ten seconds the entire compound had gathered. Our own servants appeared at the side of our house. One of the single ladies came out on her front porch, and the servants from the other half of the double house stood at the corner of that section.

Getting ready to mount, I realized that another investment would be a pair of clips. I rolled the bottom of my right trouser leg around my ankle and pulled my sock up over it.

This was no time for doubts. I wheeled my bike out, got a good running start, and mounted. I wobbled badly going

around the first time, but I made it, not letting my eyes look at anything but the gravel. The second time I rode better, though I misjudged the rise to the front gate and wove back and forth desperately to make the grade. Coasting down, I forgot about the brakes and put on the front one first, resulting in a bad jerk. But I kept my seat, and the third time I performed well. I came to a stop at our front steps and dismounted, almost losing my balance, but not quite.

I appreciated the smiles and murmurs of approval from various spots in the yard.

"That's not half bad," Father said.

"No, it isn't," Mother agreed. "But you still have a way to go. You must learn not to wobble before you go out into traffic, and you hunch over badly as you ride, showing how tense you are. Of course, you'll learn to relax eventually and enjoy it."

Turning to her I said, "I just began riding this morning, after all. You have no idea what it's like to learn to manage a bike, anyway, and especially alone."

My voice had cut through sharply and she responded with, "Oh, haven't I? What makes you think that?"

Before I understood what she was doing, she had tucked up her skirt, wheeled the bike over to the steps, mounted, and taken off.

She, too, wobbled, but only two or three times, and she sailed around the circle, laughing. The second time, she waved a hand at me and called out, "So I don't know what it's like, do I?"

And the third time, she rang the handbell, something that I hadn't attempted.

I should have been standing there with my mouth slack

according to the best tradition of this sort of episode. But my mouth wasn't in the least slack. It was clamped shut and my jaw muscles worked in total rage at this revelation that both my parents could ride a bicycle and neither had lifted a finger to help me.

For a moment I felt utterly humiliated, but then I understood that the gods had finally smiled when Mother called out, "Next time around you must help me off, John. I can't get off a man's bike without help." An edge of concern colored her voice.

"If you are such a good rider, you can manage it, I'm sure," I called to her.

I saw Father's head go back, but I knew he wouldn't step between Mother and me on something like this.

The other single lady appeared in a second-story window. Mother looked marvelous, if not exactly the image of a conventional mission wife, her skirt and petticoat streaming behind, her hair loosening.

"You must help me!" she called.

"What is it worth?" I asked.

"What do you mean?"

"I'll need a kickstand and a lock," I said.

"What are you trying to do?" she called back.

"Help you learn to be independent."

"It's unfair," she answered, but she rang the bell again and that clinched it for me.

"No kickstand and lock, no help," I said.

"Now, John!"

"I didn't ask you to ride my bike, paid for with my own money. You just took it away. Please bring it back."

"I want to bring it back," she said, "but you must help me."

"A kickstand and lock?" I asked.

"Oh, John," she said, whizzing by, but she began to laugh.

"Really, John," Father said, "don't you think you had better help your mother? The situation is—well—a little strained—I don't know."

"I'll need some clips, too," I said.

"What's that?" he asked.

"I'll need some trouser clips," I said. "I'd certainly thank you for them."

He looked at Mother, her hair blowing out looser and looser.

"Of course," he said.

"Thanks," I said and stepped into the drive. "You promise a stand and lock?" I called to Mother as she went by, flushed, no longer laughing. I waved a hand.

"All right, all right!" she called from the far side.

"Then slow down and I'll catch you," I said.

I stood in the middle of the drive. She backpedalled as if she had a coaster brake. "Use the handbrake!" I called. But she had grown flustered, and the speed at which she approached almost took me off my feet. I ran along and held her steady until we stopped and she jumped down.

"Really, John," she said, "you behaved rather badly."

"What about you?" I returned. "You didn't even ask my permission." I allowed myself a grin as we turned.

"Well," she said, beginning to smile as she tucked in her hair. "But what you did—it's a little shaming in public."

"Father's buying me a pair of trouser clips," I said.

She couldn't help laughing at that, but stopped as Father came to meet us. "Now, John . . . " he began.

Mother interrupted him, "Oh, Morton, let's relax. It was marvelous fun even if it involved a touch of blackmail."

"It wasn't blackmail at all," I said.

"What would you call it, then?" she asked, probably knowing what she was stepping into.

"Just a matter of balance, Mother," I said.

Charms to Soothe

FTER THE KULING AMERICAN school, where I had been a boarder, failed to reopen in January of 1927, I returned to the Shanghai American School, which I had entered in the first grade. Chiang Kai-shek's northern march continued, as well as the Kuomintang's shaky unification of China, making the interior provinces more hostile than usual to foreigners. My father had been the first principal of the Shanghai American School, in the academic year 1912-1913, during which I was born in a residence on North Szechuan Road. Each time I came back to what we familiarly called S.A.S. I felt that as its unique son I deserved

a special welcome, but my classmates never made much fuss over me. A freshman in the four-year high school now, I was greeted with nothing more effusive than, "Well, I see you're back again."

This final return, however, did give me an unusual status both at home and in the school. My sister graduated with the class of 1927 in June and went on to college in America by way of Suez and a summer tour of Europe, thus depriving me of the one confidante of my youth, though I moved into a closer relationship with my parents. And at school I enjoyed being not only a boarder, and thus an insider in a way I had never quite been as a day student, but an insider who had the option of going home to the mission compound at South Gate for the weekend whenever I wished.

Thus it was to me that Mother spoke one weekend of something that obviously both amused and worried her. "Did you notice anything different coming into the compound?" she asked that Friday afternoon.

"Not really," I said, taking my cup of tea from her and settling into the Morris chair in our living room. "The gatekeeper at the Girls' School looked down his nose at me the way he always has and pretended to be shocked at the prospect of a single male wheeling his bicycle through the grounds unchaperoned. You'd think he'd be tired of that joke by now."

"Some jokes never date, I suppose," Mother said. "In fact, they get more pointed with the years."

"No doubt," I answered. "A lot of wonks ran around barking and fighting just there, coming closer than usual."

"Ah," Mother said, nodding, "so you did notice."

"They never really worry me," I said, "but ever since I was

snapped at by a wonk a couple of years ago on a hike out of Kuling and had my coat torn, I've been wary of them."

"It's just as well," she said. "You used to be almost foolishly fearless that way."

"I know," I said, thinking of the many half-wild dogs I had encountered outside villages and mountain towns and in the various Chinese areas of Shanghai itself.

Everyone called them "wonks." A mixture of all breeds, they belonged to neighborhoods and towns, scavenging and barking at strangers. They mated in the open to my puzzled interest when I was younger and to the embarrassment of all the adults whom I asked about these pairings. Father took me aside and delivered a stately lecture on reproduction, which I didn't fully grasp until the following day when the cook added to it in Chinese with specific canine and human details and some firm handling of his own body as well as mine.

Mother brought me back to the present. "I'm afraid you'll have to get used to them for a while."

"Oh, I'm used to them," I said, "but there were so many, and even in the old graveyard when I came through our back gate past the wall."

"That's what I'm talking about," she said. "It's both amusing and annoying, but Nancy Parker, of all persons, has decided that wonks have been neglected, that they need affection and care, and that if they are fed regularly and even petted—she's already been slightly bitten—they can be tamed and will respond, the poor things."

"But that's silly," I said. "A wonk is a wonk—it eats up garbage and has its own life. Wonks aren't really mean, they're just suspicious of strangers and bark at them, which

isn't a bad thing. And they never starve—people toss them all kinds of stuff."

"Of course," Mother said. "Having been born and brought up in China, you have that feeling and it's sensible. The odd part is that Nancy was born in China too, but she left early, and now that she's back she's smitten with this notion of service to the wonks. She feeds them in the old Chinese cemetery every morning and evening. Even Nancy can see she mustn't let them into the compound, but I suppose she thinks that once they've grown tame and civilized no one will mind."

"She's crazy," I said.

"Oh, I wouldn't say quite that," Mother began slowly. "She's a young, energetic girl—woman, I should say, by now. She's come back to the mission because she thinks it's her inheritance, as if she had missed something in college in America. Though she's quite a good teacher she's really very—well, restless is perhaps the best way to put it. She needs to find a release for her—impulses, perhaps."

"She could find a hundred better things to do."

"But she has pitched on this one," Mother went on, "and I don't want you to make fun of her—I mean to her face."

"I'm really the one to do it," I said. "Like Nancy, I'm partly Chinese in my mind. We've had quite a few talks recently about that and I could explain to her . . . "

"That's just what you mustn't do," Mother interrupted. "I'm glad your father hasn't come in yet. You must realize that Nancy is very fond of you, that you are both, as you say, partly Chinese, but you must also remember that you are at least ten years younger than she. You've just begun to shave."

"I need to almost every day," I said, "but I don't see what that has to do with it."

"It might have quite a bit," Mother said, "if you would only think about it."

"Ah," I said, totally at sea and missing my sister greatly.

"I'm sure I've made everything clear, then," Mother said, just as Father came in. I jumped up and carried him his cup of tea.

"I've been talking to John about Nancy and the wonks," Mother said.

Father snorted. "I don't see why she doesn't organize a special class in geometry. That's what she's really good at. She's talked with me at length lately about my ideas of moral illustrations for Euclid's proofs."

"I've noticed that," Mother said. "She's looking for something quite different from her regular work."

"In some ways it's all rather like . . . " I began and stopped.

Father looked at me. When I failed to continue he said, "You were going to say? You still sometimes begin a sentence and fail to complete it—an irritating habit, as I've told you before."

"I'm sorry, Father," I said. "I was thinking of a kind of parallel, but I realized it was probably a false one and gave it up."

"A parallel?" Father said. "Parallels are often dangerous, and so are analogies. Metaphors are particularly misleading." He looked at Mother, whose taste for fantasy and figurative language bothered him at times.

"Different modes have different uses," Mother said, smiling. "Maybe Nancy should try a little music on her new friends."

"Music?" Father asked.

"You know," Mother said. " 'Music hath charms to soothe the savage *beast*,' as we used to say in high school."

"I'm surprised to hear you misquote," Father said, tossing his head back. "Surely it's 'breast'—'the savage *breast*'— isn't it?"

Mother hesitated. "I did say in high school, didn't I? And of course you're right." She was trying not to laugh. "In fact, well, what I meant—oh dear, I'm afraid *I'm* the one not going to finish my parallel or sentence or whatever, this time."

We all laughed. Mother gave us fresh tea and I passed Father the sponge cake as we turned to the news of the day.

I felt relieved, because I knew that my parallel, which could hardly have been Mother's, would have been badly misunderstood. From the Chinese corner of my mind I had thought that Nancy's efforts with the wonks wasn't all that different from the whole mission pattern that I had been brought up in and was beginning to think I wanted to get out of. Not that I drew any exact parallel between the wonks and the Chinese, which Father would have belabored me for, but the entire direction of energy struck me as similar.

Mother must have continued in her own private parallel for a time, dropping comments absent mindedly into our general exchange and smiling to herself, while Father discussed the new government's centralization.

A couple of weeks later I said to Mother on getting home, "I met Nancy Parker when I came through the Girls' School grounds and she asked me to go with her this evening to help feed the wonks. I didn't see how I could refuse."

"No, it would have been impolite," Mother said, looking

at me closely. "Come to think of it, John, it might be wise for you to continue around the curve of the road to our own front gate now, rather than coming through the Girls' School. I know you're used to that and it's shorter and you've done it all your life and there's nothing wrong about it. I don't think you shaved very well this morning—you missed a line along your left jawbone."

I grinned. "Goodness, you really jump around! If Father were here he might ask you for a transition."

"I might just find one," Mother said. "When is Nancy expecting you?"

"In about an hour."

"That will be convenient," she said, "because I want her to come to tea tomorrow. I'll write the invitation before you go."

"I can remember it," I said. "She won't think that too informal, surely?"

"Probably not," Mother said, "but I particularly want her to be here, so you can carry my note and bring me her answer—she won't need to write that."

As I went through the kitchen on my way to meet Nancy, I asked the cook in Chinese if he had any scraps I could take along for the wonks.

"I have no scraps," he said.

"You ought to be able to find something," I said.

"Perhaps I could, but I choose not to," he said.

"Oh, come on," I said. "I've promised to go over there, stupid as it all is, and I ought to bring something out of politeness."

"I'm happy you say it is stupid," he said. "Ordinarily I would find something for you to take out of politeness, as

you say, but if you take nothing Miss Parker may understand that this house is not supporting her folly."

"You really sound worked up," I said. "I know it's ridiculous, but I don't suppose it harms anything, though Mother says Miss Parker has been bitten once."

"It harms a great deal," he said. "Not only are all of *our* wonks attracted to these free meals, but the other wonks are attracted as well, and that makes for bad feeling with the nearby neighborhoods. Even worse, *our* wonks are becoming lazy and not earning their proper place in *our* neighborhood. Spoiled food thrown into the street is not always eaten. You know yourself, also, that this is a period of strong anti-foreign feeling."

"Yes, I get shouted at a good bit once I've left Frenchtown," I said, "but I don't think it's dangerous. After all, everyone's used to seeing me ride from West Gate to South Gate. And if anyone shouts a dirty name at me I call back in Chinese and they laugh. I even swear a little sometimes just for fun, or complain against the foreigners myself."

"Of course," he said, "you also look a little Chinese with your dark hair, though your nose is bad. But that is not what I mean. You see, people in the whole area are complaining, saying that this is just what you can expect from foreigners— not to understand what a situation requires. The non-Christians say that it's like—but that isn't important," he concluded abruptly.

"I've thought of that myself."

"You must not say it before your parents."

"Of course not," I said. "As you say, I am partly Chinese myself."

"*I* have certainly said nothing about it."

"Nor I," I said, bowing formally.

That was too much for him and he laughed.

"I mustn't be late," I said.

"You go with empty hands."

"I'll blame it on you—I'll tell her you are the stingiest person around and cheat on your household accounts and that when I was a small boy you showed me with your hands what male and female dogs do together as well as men and women."

"Will you truly?" he asked in mock fright.

"Of course not," I said. "It would dishonor the house."

This time he bowed to me, and I said, "Oh, stop it."

I met Nancy at the cemetery gate. Hearing two or three dog fights in progress on the other side, I hesitated about going in.

"It's nothing," she said. "They're already growing tamer. They recognize me. I feel so sorry for them."

I opened the gate and we stepped through. She carried some bones and table leavings in two big baskets that she began emptying. The wonks stopped fighting and approached us.

"You see?" she said, putting the baskets on the ground.

"I do. Mother says you've been bitten. That's dangerous."

"Just a scratch," she said pulling back her sleeve. "Just feel it—it's nothing."

Before I could stop her she had taken my right hand and run it over her forearm.

"You should try to touch them," she said. "That reddish brown one comes very close."

"He looks awfully wild to me," I said.

She still held my hand and now she pushed me forward.

"Really," I said, "they don't know me yet."

"You should try, anyway," she said. She shifted her hold and somehow she stood behind me now and shoved against me. I stepped forward, having felt her body against mine. The wonks wolfed down the bones and fought over the leavings.

Nancy kept pressing against me and laughing, saying, "See? I know they're getting friendlier."

"I think they have a long way to go," I said. Then I remembered the invitation. "I'm glad I haven't forgotten," I said, turning. "Mother particularly wants you to come to tea tomorrow. She's even sent a note, but you can just give me your answer." I pulled out the envelope and she opened it.

"That's very kind," she said. "Yes, of course I'll come. But just who is this Mr.—goodness, what a fancy name, with a particule and everything—Mr. deCourcy?"

I glanced at Mother's note. "Mr. deCourcy?" I said. "I've never heard of him. But really, Nancy, I'm surprised you're trying to tame these wonks. You know, they have their own place in the neighborhood."

"But they are so untended," she said. "I yearn over them." She reached out as if to touch me again. I tried to back off not too obviously, saying, "They've always seemed to manage." The wonks had finished eating by now and I was glad to get back through the gate. I said goodbye to Nancy and when I got to the house I found Mother upstairs and told her her invitation had been accepted.

"Good," she said.

"And I take it there's a Mr. deCourcy coming?"

"Didn't I mention him to you?" she asked blandly. "He's a widower from a station near Canton."

"No, you didn't mention him," I said. "And I don't recognize the name."

"He's from the South," she said.

"Well, of course, if he's from Canton," I said.

"Don't try to be clever. He's a Southern Presbyterian."

"Oh, well," I said.

"You sound very silly, John," she said. "As a matter of fact, he is coming to stay for the weekend. I met him at the Missionary Home and he seemed lonely. His children are young, not old enough to come here yet. He's on some kind of mission business and I thought he would enjoy staying with a family."

"I see," I said, thinking that for once I possibly did.

"That's good," Mother said. "Be sure to wash up before dinner, especially after being close to those wonks. And you might give yourself another shave. Your beard is going to be darker than your father's and is beginning to show."

When the Rev. Mr. Richmond deCourcy arrived in time for tiffin the next day, he struck me as mildly dull. I listened to his accent and looked at his luggage, which was of excellent quality and included a leather hatbox.

Mother had invited only Nancy Parker to tea, it turned out, and Nancy grew quite vivacious during that usually relaxing meal.

Mr. deCourcy also seemed to wake up a bit, and when it was over, Nancy, to my relief, carried *him* off to help her feed the wonks.

When he came back he said to Mother, "It certainly shows a loving spirit, doesn't it, to want to tame and care for those animals?"

"It does," Mother said. "Nancy has a warm heart, though

in this instance her affections may be somewhat misdirected. She is charming with young children."

"I was afraid she might be injured," Mr. deCourcy said. "I told her so."

I was on the point of saying it was all idiocy, but I caught Mother's eye and kept my mouth shut. I excused myself and went out to the kitchen.

"You may sit down and have some tea," the cook said, "but don't get in the way. Your mother is particularly concerned over this meal."

"That must be because I'm home for the weekend," I said.

"How clever you are," he said.

"His luggage is very good," I said.

"His clothing also. Not everyone travels with a hatbox."

"People from the southern part of America are sometimes fussy about that kind of thing."

"It's good of you to share your wisdom, Little Brother," he said. "I understand his children are motherless?"

"I hardly think he would be here for the weekend if they weren't," I said.

"Your mother is a very wise woman," he said.

"That's one reason I'm so clever," I said. "My father is not a stupid man, so far as that goes."

"His knowledge is not always the same as your mother's."

I tried to put "You can say that again" into the Shanghai dialect, but it didn't come out right and I gave it up.

Mr. deCourcy was still at the house Sunday afternoon when I rode on my bicycle back to school. I heard later from the servants that he had even stayed on late into Monday.

When I rode back home the next time, carefully skirting the Girls' School and tooling around to our own front gate, I

learned of a few changes. Mr. deCourcy had found his mission business taking longer than he had expected, and Nancy Parker, having been born in China, proved a useful guide to Shanghai. Instead of feeding the wonks herself she had turned that chore over to her servants. The cook said, "They have to go out and pretend, but it is already better."

Mr. deCourcy kept turning up and Nancy Parker grew more and more animated. The wonks went from two feedings a day to one and then scattered to their old haunts.

Mr. deCourcy went back to his family. Nancy Parker accepted an invitation to Canton. She made a quick trip and when she got back she told Mother that she yearned over the young deCourcys. She added that Mr. deCourcy would be coming to Shanghai soon and for a reason.

When Mother told me this, she assured me that she had put on a fine display of pleased astonishment.

In the end, only Father showed the slightest surprise when the engagement was announced and an almost immediate wedding planned.

"Isn't that interesting?" he said. "Who ever would have thought that Nancy—you know she always seemed a bit over-intellectual, not much interested in—of course with Euclid—well, you know what I mean."

"It would be easier to be certain if you completed your sentence," Mother said.

Mr. deCourcy became our houseguest when he returned for the wedding in the South Gate church. He arrived this time with *two* leather hatboxes. One held his ordinary headgear, the other his top hat, in which he looked quite impressive, especially for a Southern Presbyterian. The cook and I surrendered.

The neighborhood wonks barked at the wedding party coming down the church steps, and a couple of them came in closer than they normally would have, but only I noticed this—certainly not the new Mrs. Richmond deCourcy.

At home, after we had seen them off, Mother said, "I was right about the music, wasn't I?"

"What's that?" Father asked.

"The music—you remember, I said she should try a little music—'Music hath charms to soothe the savage beast.' "

"You've misquoted it again," he said. "It's *breast!*" Then, as Mother and I grinned at each other, he said, "Are you telling me you intended to?"

"It's not important," Mother answered. "I wouldn't have picked the Wagner, myself, but it's really Nancy's affair, isn't it?"

"I'm not sure that's the appropriate word," Father said, glancing at me.

Mother let it pass, but when she received a letter a few days later signed "Nancy—in Paradise" she showed it to me and said, "Don't quote me to your father, but 'affair' may not be wide of the mark."

"At least it isn't yours any more," I said.

"Mine?" she said. "What would make you say it was ever mine?"

"My native cleverness," I said. "As the cook points out to me from time to time, I am your son."

"So you are," she said, "but you're also your father's and I do wish you'd learn to shave more carefully. You've missed your left jawline again."

The Rival

HENEVER QUESTIONS OF CEN-
sorship come up, I find myself thrown
back to my boyhood. Though they may
have had some qualms, our parents let my
sister and me read anything we wanted
to, with, for me, just one exception to prove the rule.

This wasn't quite so liberal as it may sound; for the
resources available to us in Shanghai were limited. We had a
good supply of books at home, including most of the stand-
ard English and American novelists of the eighteenth and
nineteenth centuries, and collections of the major poets.
Father's library, housed in his study, ranged from biblical

concordances and harmonies of the Gospels through some collections of nineteenth-century sermons, to the works of William James, John Dewey and others, including at least one work of Jung's. As a whole, it reflected a strong emphasis on pragmatism in educational theory and intellectualism in theology—the first the result of his having taken his M.A. at Teacher's College, the second his inheritance from a Covenanting mother and a Presbyterian father.

Our magazine subscriptions included the *Atlantic, American Magazine,* the *Delineator,* the *Saturday Evening Post,* and the *National Geographic.* One of the single ladies, whom we called our Courtesy Aunts, Miss Bess Hille, received current poetry and fiction from her sister in Bath, New York, and she shared these with Mother, so I had some sense of what was going on in American letters.

By the time I reached high school and began to buy books for myself, I was drawn to Hardy. I also had the early Modern Library to choose from, and began to read some Oscar Wilde, D.H. Lawrence, and Virginia Woolf. Whatever my parents thought of this, they never openly criticized my choices, though I knew that Father felt I should be devoting my time to the sermons of Henry Drummond rather than to *Sons and Lovers* or *The Importance of Being Earnest.*

The one exception shows the strength of reaction in port-city society to what were called "mixed marriages." The two books that were not so much forbidden me as simply made unavailable came from such an innocent source that they struck their American and British readers as even more sensational than if they had been written by an acknowledged radical or social reformer.

Few readers today, I suspect, know the novels of Louise

Jordan Miln, though copies of her work still turn up in thrift shops, bound in pigskin yellow with black lettering in "Oriental" style. The *National Union Catalogue* lists twenty-five titles, and I had read at least five of them, including *In a Shantung Garden* and *The Flutes of Shanghai*. Almost all her fiction treated Chinese life as if anyone of interest belonged to a centuries-old family, cultivating the highest esthetic tone on the one hand and eating elegantly on the other, cared for by devoted family retainers. They hadn't much connection with the life I saw immediately outside our compound in the crowded houses of Nantao, or the streets and alleys I rode through on my bicycle. But in *Mr. and Mrs. Sên* (1923) and *Ruben and Ivy Sên* (1925) Mrs. Miln startled her readers by writing of a mixed marriage and its consequences. I had heard talk about the two books, so when Aunt Bess brought them over one Saturday afternoon that I happened to be home from school and left them for Mother, I picked up *Mr. and Mrs. Sên* and began to read. I couldn't have finished the first chapter before Mother came into the living room, glanced at me slouched in the Morris chair, and said casually, "I see you're reading one of those books that Bess Hille said she would pass on to me."

"Yes," I said. "I've heard about them, of course, but so far I haven't read anything but a description of a prejudiced Southern lady."

"That's interesting," she said. "It's time for tea, and since your father said he might be kept late at the school we'll start now. I think we should use the dining room, because that will keep you from slouching so much, and we have a variety of cookies and cakes, so it will be more convenient."

After the servants had set the table, Mother led the way.

Father came in shortly, and though I'm still under the impression that we all finished tea together and left the table at the same time—Father to go to his study and Mother to the kitchen to say something about dinner—I can only assume that Mother got up when Father came in. I refuse to believe that Mrs. Miln's books disappeared from where I had left them through an act of sheer will. But they were certainly not there. I thought of following Mother. Then I understood that for the first time in my life a book—two books, in fact—had been taken away from me. I said nothing, confident that I could find them.

I failed. I had long since learned to pick the two locked drawers of Mother's bureau, and Father had given me the combination to the small iron safe containing some family papers and a supply of ready cash. I couldn't believe a hiding place existed that I didn't know about. But I never found the books, and though I was piqued by the mystery of their whereabouts I gave up at last. I was reading Wilde's *Salomé;* I had discovered T.S. Eliot in Conrad Aiken's *Anthology of Modern Poets,* and Marianne Moore in a couple of Jessie B. Rittenhouse's anthologies.

I wasn't personally much concerned over mixed marriages, though I had absorbed most of the standard prejudices of port-city society. I grew up with a strong anti-Japanese bias, acquired from the servants, and a dread of being called Portuguese, which was the "polite" way of suggesting that a person might be Eurasian.

Our cook married off his son by his first marriage at the age of sixteen and told me that I, too, was ripe for marriage and that my parents should be doing something about it. I could see my last year in high school ahead of me and at least

four years in an American college before anything like that could happen, and even then I wasn't so sure. The cook would go on, saying it might even be possible to make a match with a girl from his home village.

"Your hair is not the best color, though it is dark," he would say, "but you begin to look barbaric now that it is coming out on your face. But it could possibly be arranged."

"Thank you," I said. I agreed that my hair, by now a very dark brown, wasn't quite the only right color for hair—coal black.

The cook was pulling my leg. I eventually realized that the idea of marriage for me with a girl from his home village struck him as hilariously impossible, but I kept up the game. Perhaps he indulged in some erotic fantasies as he put forward suggestions, solemnly and judiciously, balancing possibilities, muttering family names under his breath. He might even speculate on my capacities as a husband and where we would live in Shanghai. I noticed that he never discussed this in front of his own wife, our amah, who would have scotched it in a second.

The individual mission policies puzzled me. Though the Anglicans could hardly be said to approve of mixed marriages, they at least tolerated them. We knew one family from the days when Mother, before she had met Father, taught at Miss Jewell's School in the International Settlement, the husband English, his wife Chinese, with a daughter and a son. The daughter lived, I came to understand, an almost intolerable life. She had money, her own property, even her own boat at one of the summer resorts we often went to, but she had no future. She was grateful to be welcomed in our house and she entertained us lavishly in hers. Her brother, on

the other hand, could opt for upper middle-class Chinese life and married a Chinese woman.

In contrast to the Anglicans and the American Episcopalians, the Presbyterians not only frowned on mixed marriages, but any member of the mission who made one was expected to resign. My mind's simplicity reveals itself when I say that I once undertook to discuss this issue with Father. The mission's policy seemed to me to contradict the principles of Christian love I heard about constantly and the repeated insistence that all souls were equal before God.

As Father grew more and more autocratic during our exchange, I gathered that whereas there was certainly a kind of equality in Heaven, "practical considerations" on earth controlled a number of issues. The distant echoes of Calvinism were troublesome—though surely, I said, he didn't doubt that the Chinese members of the South Gate Presbyterian Church, who held themselves above the Seventh-Day Baptists at West Gate and the Roman Catholics in between, felt themselves pretty much among the elect.

I had to leave it there. Father said, "There's no point in saying anything more, John. When you are more mature you may understand."

I heard the dismissal in his voice and said, as I rose, "I trust that I shall."

From the toss of Father's head and his stare at me, I knew it was time to leave his study, and quickly.

One intimate reminder of the issue touched me before I left China. The non-denominational American Community Church on Avenue Pétain stood almost directly opposite the Shanghai American School. Father served on a number of committees, one of which met early that particular Sunday.

The Rival

We had agreed to meet for the morning service, after which Father would drive back to South Gate and I would return to the school for Sunday dinner.

Like most ministers' children, I imagine, I early perfected several techniques for surviving sermons—counting games, making knight's moves through the congregation using bald heads, or brown-haired, or ladies' hats for jumps; betting my right hand against my left on which side of the center aisle the next cough would come from; or what the division would be in the Lord's Prayer between "debts" and "trespasses." I had, after all, heard everything, and more than once, by the time I turned ten.

Father rarely approved of any sermon he heard. In many ways he was ahead of his time. When he himself preached, he even used supplementary material in the pulpit—diagrams, drawings, charts, mottoes. I found them vulgar, but I had to admit they offered something beyond the familiar exhortations and rhetoric.

On this particular Sunday, just as I was beginning a counting game, Father surprised me by nodding vigorously in agreement with the minister, a young man whom he considered a lightweight both in theology and scholarship.

I dropped my game and listened. The minister wasn't talking about scripture or theology or the social duties of a Christian to himself and others. He wasn't up to explicating obscure passages in Hebrew or Greek, about the only things I still found interesting. Instead, he was speaking lyrically about the joy of a man wooing a woman and winning her over a rival. I could tell Father enjoyed this tremendously. He smiled and squared his shoulders, shifted in his seat, crossed and uncrossed his legs—all forms of behavior that I had been

taught to avoid during church services. I knew he must be reliving a triumph out of the past.

My first reaction was to wish that my sister was still in Shanghai. For years we had fitted together bits of information about our parents' courtship. I can't remember how old we were when we began to notice certain hesitations in their accounts, but I am sure it was my sister—always shrewder than I in such matters—who first caught them. Neither of us could be accurately described as guileless, but whereas my sister was better at pouncing on inconsistencies, I, primed by her, was the blander, less suspect asker of the innocent questions. Over the years we had come to the conclusion that Father had had a rival.

I hardly think that the phrase "extended family" had come into use at that time, but we had one through Mother's wide range of acquaintances in the international community she had known before she met Father, and we called almost all of them our Courtesy Aunts and Uncles and were closer to their children than to our cousins in America. We agreed that whatever had happened, Father's rival must have been, might even still be, a member of this circle.

Looking out of the corner of my eye at Father feeling happy with himself in some earlier time while the minister chanted on about the nature of love and competition, clearly living in *his* personal memories, I reviewed what my sister and I had put together from all the clues we had picked up and followed. By the time my sister left Shanghai we had pretty well settled on our Courtesy Uncle Cedric, a single Scots businessman. We saw him rarely, but when we met we both felt there was something just a little different from the others in the way he behaved toward us.

46

The sermon over, the closing hymn sung, the benediction pronounced, Father and I walked out the front doors of the church. Father was extraordinarily cheerful as he greeted his friends, made all the correct remarks to everyone, and even waited to congratulate the minister on his "stimulating" sermon, which, by Father's usual standards, had been a poor one—sentimental, almost non-Scriptural, and without reference to the duties of a Christian in the modern world.

Father and I said goodbye after I told him I would be coming home the next weekend, probably bringing with me a White Russian classmate.

"Excellent, excellent," he said. I knew my message wouldn't get to Mother and that I would have to drop her a note.

Luckily, as it turned out, my friend, Eugene Kazack, couldn't make it after all; so on Friday afternoon I rode home alone on my bicycle.

"I don't know, Mary," I heard Father saying as I went down the hallway after closing the front door quietly, as I had been taught. "You must do just as you think best."

"But you understand that *they* have asked me to do this," Mother said, "and in so many ways I owe them all a great deal."

"Yes," Father said.

Something in the tone of this exchange differed from the conversations that my arrival sometimes put a stop to. These had largely, I assumed, to do with the drug addicts or criminals Father was interested in, or mission gossip they thought I shouldn't hear—though I usually got all of it from the servants before it reached them. No, this was something

else, and though I thought they must have heard me coming in they obviously hadn't.

Mother said, "Well, I think it *would* be a mistake. Just imagine, outside the merely social implications—the possibility of children—surely you must understand."

"As I've said," Father said, "you must do just as you wish, Mary, but considering the circumstances, I'm not sure that you . . . "

"But that's exactly it," Mother interrupted. "You don't think the others haven't tried to dissuade him, surely? It's just that they feel as a last resort that *I* might have some influence, and you know they are all closer to us as a family than our relatives in America."

"Quite so," Father said. "Have you agreed to it?"

"Yes," Mother said. "That's what I've been trying to tell you. We are having tea tomorrow at the Astor House."

In what struck me as an endless pause following this, I began to feel embarrassed and guilty. I tiptoed back to the front door, opened it, slammed it shut, and walked in saying, "Gee, I'm sorry I'm so late. Old Kazack couldn't make it— some Greek Orthodox holy day coming up—and the bike ride took longer than usual because there was some kind of fair going on at West Gate. I hope there's something left."

They both turned to me, not even rebuking me for slamming the front door and saying "Gee!"

"There you are," Mother said, "and we not only have hot tea left but plenty of the peanut cookies you're so fond of."

I sat down and drank my tea, wondering how I was going to dig out the facts. If the servants were in on it I wouldn't have any trouble, but after we had finished and I went to the kitchen I found they knew nothing.

Next morning at breakfast I asked Mother if she would have time in the afternoon to give me some help with my Latin.

"Perhaps when I get back from town," she said.

"Oh well, any time," I said.

Father said, "Your mother feels it necessary to have tea with your Uncle Cedric this afternoon at the Astor House."

"Feels it necessary?" I questioned daringly. "I haven't seen Uncle Cedric in years, but it's always nice to have tea at the Astor House, especially when someone else is paying for it."

My joke came off with the degree of success it deserved.

"Ordinarily I wouldn't do it," Mother said carefully, "but, since you're bound to hear about it from someone, I may as well say now that your Courtesy Uncle Cedric plans to announce his engagement to a Miss Chiang, whom he has known, I gather, for some time. The whole family is upset."

"Oh dear," I said, "I can't really see . . . "

Father wouldn't give me a chance. "John, we had a discussion on this subject some years ago, and I don't think there is anything for you to add."

"As you say, sir."

"I know it may seem unjust to you," Mother said, and I knew the full force of my "sir" had hit them both. "But as you grow older you will, I'm sure, come to understand some of the problems."

"I understand the problems perfectly well," I said. "Haven't I lived with them all my life? Haven't I seen how Olivia Jarvis suffers, while her brother gets along? Haven't I seen 'Chinky' Prewitt living with his nickname? Haven't I, for that matter, listened on the streetcars to people who think I don't understand Chinese speculate on *my* ancestry?"

I had gone too far and given myself away.

"Surely you always ride first-class?" Father asked. "You know that as Presbyterians we always ride first-class and we always give you the money for it."

I was caught. When my sister and I used to ride the streetcars together—and even now when I rode them alone— we always rode third-class and saved the difference for candy, my own favorite being sesame-seed rolls.

"Well, I ride my bike now," I said lamely.

"Truly, John," Father said, "I don't think you realize the importance of certain standards."

"Probably not," I said.

What was the use? We weren't living in one of Louise Jordan Miln's novels. We were a Presbyterian Mission family of three, one of whom had already shucked most of his Presbyterianism.

I turned to Mother and said, "I can probably work out the Latin myself if I put my mind to it."

Mother rode up to town that afternoon after dressing with no more or less than her usual care. As always, she carried gloves. She returned no earlier and no later than usual, but she went directly upstairs after asking for the amah, an expert in massage, to come to her. From time to time Mother fell victim to what were then called "sick headaches," and the amah, using two coins between her fingers would pinch the back of Mother's neck and shoulder muscles, working out the pain and tension.

After a while Father went upstairs and came down soon to tell me that Mother would not be dining with us, and went into his study. I looked at my Latin passage and finally puzzled it out, having failed to recognize a perfect infinitive.

At dinner Father and I talked along in a meaningless way, until he happened to refer casually to an ongoing minor clash between one of the lesser warlords and the Nationalists. I said, hoping to distract him, "At least, Father, you're not getting your orders to proceed immediately to the scene of the conflict!"

My hunch had been a good one, taking Father back to the days when he was on his way to China by way of Europe, not only as a member of the mission but also as a certified representative of the Keystone View Company, equipped with pounds of photographic apparatus, including the heavy, double-lensed camera used for taking stereopticon slides. He was already an experienced photographer, but the company showed little interest in what he sent back from Europe, saying they were well stocked in those areas.

He smiled at me now. "No, that's one thing I needn't fret over," he said, and for a time seemed to be reliving a reverie. I was careful not to break into it. The Keystone home office became enthusiastic over his work only after he had reached China. Most of their Chinese slides showed urban scenes. Father, touring through the country districts where he would later set up a series of day schools, came into direct contact with village and country life. He had assured me once that he had felt it unwise to take pictures of nursing mothers because the effect might be, as he said, "misleading."

During one minor clash between upcountry warlords, the international press, with nothing else to exploit, blew it up into a major revolutionary crisis. Father received a cable instructing him to proceed immediately to the center of conflict with all expenses paid and all pictures to be bought at a bonus rate. He also learned, to his dismay, that Keystone

had informed the press that their personal representative was hurrying to the scene and they would soon be able to furnish on-the-spot pictures of this critical, world-shaking conflict.

Father always admitted that the proposal attracted him. He could have loaded his equipment, taken along a couple of body servants, worn his pith helmet at the rakish angle he liked, and been off to the wars. But topee or no, Father had to weigh the attractions of becoming a crack international Keystone photographer against preaching the Gospel to the Chinese.

He knew well enough that the answer was written. His parents had written it for him in his own lifetime. Calvin had written it some generations back. And he accepted it. But he would sit sometimes, just as he was sitting now, and I could catch the gleam in his eye—visions of nursing mothers, perhaps?—and see it fade as he brought his life back into focus in the present, noticing where we still were.

He actually laughed, saying, "There you are, John."

"Right," I said. "You know it would have been something if you'd arrived a day or two after everything had stopped."

"It would, wouldn't it? I actually thought of that, but of course I simply had to cable back the impossibility of the whole proposal. Still, who knows?"

"Anyway, you take great pictures," I said, and I could see that he liked that.

When we dipped our fingers into the brass fingerbowls and I saw that he felt happy about that long-past decision, I decided to risk asking, "Did Mother say anything about her tea?"

"Very little," Father said, but without really thinking about it. "Cedric is apparently determined in his folly."

I wanted to say I thought that was great, and ask why Mother would think of interfering, but I couldn't, and I flattered myself that I had contributed a little to lightening his mood.

I have wondered ever since what Mother said to Uncle Cedric and what he, in return, said to her. I couldn't imagine him being in any way impolite, but he must surely have intimated that she was the last person in the world to give him advice on this particular subject.

Mother was up and about the next morning, looking worn. I told her I'd solved the Latin, and after Sunday dinner, following Chinese church and mission prayers, I left a little earlier than usual for the ride back to school.

"Maybe your Russian friend will be able to come next week," Mother said.

"We'll see," I said. "I'll let you know."

I kissed her and she held me close for a moment. Then I got on my bike and started back. I wondered how I could write it all down for my sister.

I'm happy to say that Miss Chiang and Uncle Cedric went right ahead with their marriage and so far as I knew it was a success. They had agreed that at that time and in that place children were out of the question. The extended family received them from time to time. At the French Club— otherwise Le Cercle Sportif Français—they faced no problems. I never again discussed mixed marriage with either of my parents. The first time I encountered the word "miscegenation" I had to look it up in *Webster's* to be sure it meant what I thought it did.

The titles of Louise Jordan Miln's two controversial novels remained at the lowest level of my consciousness. I couldn't

quite work up the energy to track them down in a library after coming to America. In the winter of 1936-37, however, I was up at Merton College, Oxford, and I thought it would be a good idea to spend my vacation in Switzerland. After graduating from the Shanghai American School I had split a year between Europe and the States. During most of the European part, which was supposed to strengthen both my lungs and my French, I had lived in a small village, Corsier-sur-Vevey, above Lake Geneva, and Percy Alfred Scholes, the author of *The Puritans and Music in England and New England* and *A Life of Dr. Burney* among other titles, had served as unofficial guardian. I lived with the family of a Swiss National Church pastor, M. Gardiol.

Now that it was time to think about my coming exams at Oxford I thought I might return to the area. I knew that the *famille* Gardiol still lived in the area, and that Dr. Scholes was still in Chamby-sur-Montreux, finishing what was to become *The Oxford Companion to Music*. I crossed the Channel and took the night express south out of the Gare de Lyons, having made a reservation in a middle-priced hotel in Territet. After a third-class dozing night I looked forward to taking a bath and getting into bed, thinking I might wake in the afternoon and get in touch with the Gardiols and Percy Scholes.

At the hotel desk I signed the necessary papers, and while the desk clerk inspected my passport I glanced at a small bookcase in the lobby. There, side by side, stood *Mr. and Mrs. Sên* and *Ruben and Ivy Sên,* exactly as I remembered them in their pigskin yellow and black lettering. I opened the glass door of the case and pulled them out. In my room I started the bath water after a maid had brought a pot of

coffee and croissants. Once in the tub I began to read *Mr. and Mrs. Sên.* From time to time I dribbled a little more hot water into the tub. A third of the way through the novel I got out, toweled off, put on pajamas, and propped myself up in bed with two pillows. I read and read. I finished page 325 of *Mr. and Mrs. Sên* and knew there could still be no sleep for me until I had read the other book that had disappeared from our South Gate living room. I opened *Ruben and Ivy Sên* and read on.

From the beginning, the fluency of Mrs. Miln's prose and the strength of many passages surprised me. In spite of their frequent artificiality, both novels move with considerable life. Like many before and after her, Mrs. Miln tried to distinguish between Chinese and English speech by such devices as inversion and archaic forms. The problem is a difficult one, as I can attest, but I do not think that I have ever perpetrated anything quite like "Why when first you said words to me spoke you them in English?"

The Sêns are one of Mrs. Miln's old, enormously wealthy families, living in Honan, and Sên King-lo is unbelievably accomplished as he moves in the highest diplomatic circles of Washington. But Ivy Ruby Gilbert, the English girl he falls in love with and marries, is human, and Sên himself becomes human by the end of the book, which opens with the pages I vaguely remembered, giving a portrait of Miss Julia Calhoun Townsend, an unreconstructed Southern lady who says things that could never get into print today. Once in Honan, Mrs. Sên, now called Ruby, discovers what she is up against and what her husband has renounced—a vast fiefdom—to marry her. She has left their son Ruben, an infant, in England, and she longs to return. When she finds that she is going to bear

another child, permission is given by the dowager grand-mother to return. In England once again, King-lo keeps his yearning for China secret from his wife, and long before the children are grown—neither remembers him—he dies, according to his closest English friend, Sir Charles Snow, of homesickness.

Ruben and Ivy Sên carried on the tale. As their father had predicted to Sir Charles, their lives are not easy, and he had hoped neither would marry.

Ruben, though English in appearance, with curly blond hair and blue eyes—Mrs. Miln obviously held a low opinion of Mendel's laws—has a Chinese heart and mind, whereas his sister, Ivy, looks Chinese but is essentially English. Ruben, when he learns the truth of his father's marriage from Sir Charles, renounces the Chinese girl he is in love with and first met in Honan. Ivy marries the right sort of Englishman for her, but their first child, a girl, is altogether Chinese in appearance and Ivy cannot bring herself to love her daughter. One morning the infant, who has been in perfect health, sickens. By midnight she is dead. Ivy lives her life in moderate content, refusing to risk another child. Ruben loyally stays with his mother. At her death and with her previously given approval, he plans to take her coffin and her husband's to the Sên burial ground in Honan, where Ruben will adopt a boy of the clan as his son, heir to his immense fortune.

I finished page 358 of *Ruben and Ivy Sên* late in the afternoon, close to sunset. My room boasted a small balcony, and I stepped out onto it and looked at the lake and at the Grammont on the French side. I thought of Olivia Jarvis and Chinky Prewitt. I asked myself once again what Mother could have said to Uncle Cedric and what Uncle Cedric had

said to her. I thought how right it was that Uncle Cedric and Miss Chiang had married and I had to agree, grudgingly, that there were "practical considerations" and that they were wise in having no children.

Then I went back into my room, closed the glass doors, pulled the curtains, got into bed and, thank God, went to sleep.

Letterman

I N 1931, AS AN ENTERING FRESH-
man at Occidental College in Los Angeles, I
both disappointed and bewildered the senior
coach, Joseph A. Pipal, who would publish
a few years later *The Lateral Pass Technique
and Strategy* (1934) and already bore a share of the respon-
sibility for introducing the forward pass into American
football. I had signed up for a required Physical Education
course—Track and Field—because it came at a convenient
hour. After Coach Pipal discovered that I wasn't a bad high
jumper and that I could run the distances in respectable
times he took me aside and said, "I can teach you a lot in

four years. You must get away from that scissors take-off in the high jump, but as far as running is concerned you just need to keep at it and build yourself up." I was in no condition to contradict him. I stood somewhere between six-one and six-two at the time, weighing in, stripped, at 118 pounds.

But I said, "I'm not really interested in any of that. I'm a boarding-school boy and I've been through it all."

He hadn't heard me. "If you work hard this year," he went on, "you might get into two or three freshman meets, and by the time you're a senior I can guarantee you a letter either in the high jump or the distances, depending on how things work out."

"I'm sorry, Coach Pipal," I said. "I'm just not interested. I play a pretty good game of tennis, I enjoy swimming, though I'm no star, and I've climbed a bit in Switzerland. I'm a chronic asthmatic, so you couldn't count on my being up for any particular meet, and anyway, as I said, I've really been through it all."

He had heard me this time. "You mean you're not coming out for *anything?* Even when I can guarantee you a letter by your senior year—maybe earlier?"

"That's right, sir," I said with all the sophistication of my eighteen years. "I may have been competitive about those things once, but I can't get excited about them any more, though I like to watch sports events and I understand their patterns and tactics."

"I suspect you'll change your mind, son," he said, patting my bony shoulder.

We left it at that. I knew I would never change my mind, and the truth seeped into Coach Pipal during the year that he

had guaranteed a letter to a gangling freshman and the freshman wasn't interested.

In the middle of my senior year I astonished myself, my parents, and all of Occidental by winning a Rhodes Scholarship. Coach Pipal, who was, as I've tried to make clear, a decent and generous man, made a point of seeking me out and congratulating me. "I've never understood your attitude," he said, "and I'm still sure you'd be getting your track letter if you'd stuck with me. But you must have *something* on the ball, and I hope there aren't any hard feelings on either side."

"Certainly not on mine, Coach," I said.

"I just wish you were taking an Oxy letter to Oxford with you," he said.

His sincerity in saying this touched me and I said, "Well, even if I'm not, Coach, I'm still taking *one* letter with me."

He couldn't know what I meant, but he held out his hand, and his eyes glistened. We shook hands in an impulsive grip that joined total misunderstanding in him with a mild feeling of guilt in me.

As a Mertonian at Oxford I puzzled my more intellectual friends by the easy way I got on with the most zealous of athletes. I enjoyed, and still enjoy, watching sports. I could, and can, speak knowledgeably of the high jump, the distance races, and all that.

Back at Occidental in 1938 as an instructor in English, with both an honours and a research degree from Oxford, I was patted on the shoulder again by Coach Pipal, who asked me to call him Joe.

My greatest triumphs, though, came after I moved across town to UCLA in 1948. At that time we had no faculty club.

One room of the student union was set aside for a faculty cafeteria, and one corner of it contained a large round table where anyone without a companion could sit. One day I sat next to a man I hadn't yet met. After a brief exchange I asked him what his department was and told him mine. He looked interested and said he used to teach English in high school, but now he coached basketball. I'm sure John Wooden has no memories of our conversation, though we frequently sat together, but he treated me as an equal, especially after I had told him that my father had played varsity tennis and basketball in 1901 and 1902. We discussed the changes in basketball; I gave him the benefit of my wisdom; and we saluted each other in passing. My scholarly friends would ask, "How in the world do you know *him?*" And I would answer, "I'm quite an athletic type myself you know, though it doesn't show. I have a real rapport with those jocks." This was always good for a laugh since no one believed I spoke seriously.

The first time I passed the eminent football coach and "character-builder" Red Sanders after his arrival at UCLA, he smiled at me and said, "Hi there, good to see you here!" Even I felt a trifle dazed by this, wondering whom he had mistaken me for, but I came right back with, "Hi, Red, great to have you on the team." After that we greeted each other on occasion and my friends regarded me with even greater puzzlement.

I did indeed greet these men as equals. I don't know how many times during my boyhood I was told that Father's parents had built one of the first summer cottages in Chautauqua, New York, on Vincent Avenue, shortly after the founding of that cultural center. I gained the impression that

Father and his sister, my Aunt Clara, came close to being charter members, respectively, of the Chautauqua Boys' Club and the Chautauqua Girls' Club, where they added to their cultural and athletic achievements and held up both the Chautauqua and the family reputations.

Just where the C.B.C. ranks in the history of such American institutions, I can't say. As a boy I never doubted that it was the oldest boys' club in America and probably the world. Certainly it was the best, and Father must have earned his first C.B.C. letter only a few months after emerging from infancy. Aunt Clara had won so many C.G.C. letters that I wondered how either of the clubs continued to prosper after the Espey offspring outgrew them and went on to college.

This was all very well for Father and Aunt Clara, but for me it was something else again. I knew that the first summer I would spend in Chautauqua I would not only have to join the C.B.C. but that I would also be expected to earn my letter. I knew, too, that I would let the family down. My one hope was tennis, but when I asked Father about that he said, "I'm afraid there are no courts at the club, and no letter. Tennis is still thought of as a rather exclusive game socially— a little like golf. That was one of the things the voters held against President Taft, that he played golf. The C.B.C. is for *all* boys, if you understand me."

I nodded and said, "Yes," knowing I should give up right there.

My testing came in the summer of 1922, when I was nine and a half years old. My parents, my sister, and I joined Grandmother Espey, who had been a widow for some years, and Aunt Clara for a Chautauqua summer. The first Monday after our arrival Father took me down to the C.B.C. on the

lakefront, mentioned to anyone interested that he was an old boy, and signed me in. The club had been in full swing for a couple of weeks. Most of the regular classes were filled, but the secretary handed me a schedule after assigning me a locker, where I put my lunch and some sports clothes. Father said he would be off and that he knew I would have a fine time.

As soon as Father was out of sight I went to the bulletin board by the secretary's window. My eyes had caught "Letter Requirements" up in one corner on the top sheet of a thumb-tacked gathering of mimeographed pages. I leafed through them until I came to "Swimming," because I wasn't a bad swimmer. Class attendance was required, including life-saving. I'd always had trouble with that because I was scrawny for my age and height. I got the secretary's attention and asked about the classes.

"Sorry, but they're full up," he said.

"Oh," I said, somehow not surprised. "Anyway, I don't think I could pass the life-saving test."

"You're a bit late for everything."

I thanked him and turned away.

Some classes had broken up and a general movement took me toward the swimming pool, where I loitered at the edge of the deck. A sandy-haired boy about my age, lanky but better muscled than I, sidled over and said, "Hello, there. Do you have any swimming things?"

"My suit's in my locker with my lunch," I said.

"So is mine," he said. "This is a sort of general swimming time before lunch. You can just get in the pool and splash around. You don't have to try learning anything."

"I see," I said, giving one of my standard responses when I didn't quite understand what was going on.

We went to our lockers and got out our suits. In the dressing room, my new acquaintance said, "My name's Ralph Trevor."

"Mine's John Espey," I answered. I'm not sure just what I expected, but I had heard so much about my family's importance in Chautauqua that I wasn't prepared for Ralph's, "*John* I can get, but what was the rest?"

I spelled my surname slowly.

"Well, that's a funny one," he said, "but you look all right. I mean, you're about the skinniest person I've ever seen, but you know what I mean."

"I know what you mean," I said, wriggling into my one-piece black bathing suit and buttoning the left shoulder strap.

Ralph's suit was black too.

We went out to the pool.

"Can you really swim?" Ralph asked.

I walked to the middle of the pool, dived in neatly with a racing start from the side, crossed the pool, flipped over in a snappy turn, and coasted back to where he stood.

"Well, all right," he said as I hoisted myself out of the water.

"Sure," I said.

"Look," Ralph said, "I wasn't trying to sound mean."

"It's all right," I said. "Shall we swim across together?"

"Sure," he said, "as long as we don't race."

"Who wants to race?" I asked.

"All right," he said.

Ralph swam with a jerky sidestroke, so I turned over on my side and lagged a little behind him stroke for stroke.

Around us the hoi polloi of the C.B.C. splashed and yelled and carried on in the best democratic fashion.

"How about lying in the sun for a while?" Ralph asked when we got back to where we'd dropped our towels.

"Sure," I said.

"Listen," Ralph said after a few minutes. "My father is crazy about rowing. He thinks I should row in the junior division here and I've put my name down as captain of a boat, but I haven't got a crew together yet. You ever rowed?"

"A little," I said.

"Well, I was thinking," Ralph said, "you aren't really heavy, you know, but you've got those long arms and legs. They race in what father calls tubs, but he still thinks it's a good beginning for—well, you know—the Charles maybe— well, Harvard—or, if necessary, even Yale."

"My father spent a year at Princeton but didn't think much of it," I said. "He got tennis and basketball letters in college. He has an M.A. from Teacher's College—you know, Columbia in New York."

"Wow!" Ralph exclaimed. "I mean, I knew you were all right, but I didn't realize. . . . "

"Don't mention it," I said.

"Of course not," he said. "But do you think you *could* row in my boat?"

"Do they give a letter in rowing?" I asked.

"Yes," he said.

"Is it hard to get?"

"You have to pass a regular exam, I think, and show you can row certain times and distances, and then write some kind of paper."

"It sounds tough," I said. "My father's going to be upset if I don't get a letter this summer, but I don't think I can.

The swimming classes are closed. Maybe I could take a shot at rowing. Would it help to be in your boat?"

"It might."

"All right, then," I said.

Our boats were clinker-built, coxless fours, with fixed seats. I put my name down for the rowing letter exams.

Ralph wasn't much more keen on the C.B.C. than I was. Once we had gone swimming and practiced rowing—Ralph recruited a couple of grateful guys our age heavier than I was—he and I would get our lunches and drift up the little creek that ran through the C.B.C. grounds. We turned over rocks to hunt crayfish after we'd eaten our sandwiches, sometimes with deviled eggs and a piece of fruit.

Whenever anyone at the cottage asked how things were going at the club, I would say, "Fine, just fine, thank you."

My sister usually gave me a sour look as I spoke. She had seen me strolling up the creek with Ralph, but we were, after all, brother and sister, and I knew she wouldn't give me away. I knew too that she took a pretty dim view of the C.B.C., but for some reason she was under no pressure to uphold the family honor and earn a letter.

Four crews rowed in the junior division that summer. We got a little help from one of the assistant coaches. The head coach gave his time to the senior division. All but one of the boats were painted a dull flaking green. The odd one was painted black and had the reputation of being better built and faster than the others, so we had a hard time getting hold of it, and the true spirit of the C.B.C. came out as we maneuvered, even going to the length, on occasion, of getting to the club early enough to moor it under the overhanging

bushes at the outlet of a stream feeding the lake beyond the creek where we ate.

After I'd explained at the cottage why I couldn't try for a swimming letter and how hard the rowing tests were, I wasn't asked much about my club activities. I found little time to practice rowing by myself because Ralph and our other crew members grew enthusiastic over our chances of winning our division. We worked on our own, digging in with a chanted rhythm for our short-stroked start and then settling down to whatever count Ralph set. I rowed number two behind Ralph because I was so light, and the heavier of our other crew members rowed bow.

Something kept Ralph from inviting me to the hotel where he and his parents, who spent most of their time playing golf, lived, just as something kept me from asking him to come up for tea at our cottage.

The regatta came near the end of the season. Grandmother was wheeled down to the lakefront by Father, Aunt Clara in attendance, and Mother and my sister completed the group. As Ralph and I came out of the clubhouse he spoke to a couple that looked over-dressed compared with my family. He turned to me and said, "John, I'd like you to meet my mother and father."

"Hello, there," Mr. Trevor said to me.

I bowed and said, "How do you do?" Mrs. Trevor smiled.

"My family is over there," I said. The Trevors followed me and accepted my introduction.

Mother said, "I'm so happy John found such a pleasant friend for the summer."

"Oh yes," Mrs. Trevor said. "I don't think I've seen you at the golf course."

"No, I'm sure you haven't," Mother said, burying golf an icy six feet underground.

The Trevors bowed, Grandmother gave them just the hint of a nod, and the two families, never having quite met, parted.

Ralph and I hurried off to where he had hidden the black boat. Our fellow crew members were waiting and we pulled out to the starting line when the junior division was announced. Our rivals glared at us. Then we saw instead of four boats, five were coming to the start. One of the senior division crews thought this was their race. Much shouting through megaphones failed to clarify the situation.

"Get out of the race!" Ralph shouted to the seniors, but they were either confused or contemptuous, and when the gun sounded all five boats took off.

We went into our starting chant. With the boat gliding smoothly, Ralph put us into our standard stroke. We really weren't bad. We outpaced the senior crew for almost half the course, but then their weight and strength began to tell. We knew they weren't in the race, and we had already built up a commanding lead over our three rivals. But neither the Trevors nor the Espeys on shore knew, and I'm sure both Ralph and I thought of that as we gave it everything we had.

As we neared the finish, Ralph called, "All right *men!* Let's take *ten!*" We dug in, singing out the strokes as we stepped them up. We came on against the senior boat, and I've lived over half a century in the belief that with another fifteen yards we'd have taken them. Oh well, perhaps not.

Ralph gasped, "Easy all!" as we crossed the finish line. Before we had time to slump he went on, "We've got to get back and straighten out this mess." So we made a tight

paddling turn and pulled back to the club dock before the others. The senior coach and the junior assistants met us, apologetic. The senior crew came in and the coach said he was considering disqualifying them for their division. (They were not disqualified, but we had the satisfaction of seeing them soundly outraced.)

A reporter from *The Chautauquan,* having got it straight that we had won our division, asked us to write down our names for him. My longhand has never been the most legible because Father, with his Teacher's College theories, thought typing more useful than script, but I scribbled my name as did Ralph and the others.

We hurried back to our families and I told Grandmother about the mix-up. She shook her head. "The whole world is undisciplined," she said. Aunt Clara smiled, my sister looked bored, and they started back, having no interest in any non-Espey events.

In the showers, Ralph grinned and said, "Well, we did it. Dad is frightfully pleased."

"I'm glad," I said. "Are you going to try for the rowing letter?"

"Dad doesn't seem to think that's too important," Ralph said. "Anyway, I'll probably caddy for him Tuesday—some kind of tournament at the golf club." The links lay outside the Chautauqua grounds, not really part of the great cultural institution.

"I see," I said. "I've got to try for it at least."

"It's up to you. Good luck!"

"Thanks."

I trudged back up Vincent Avenue.

On Monday the paper came out and Grandmother hunted

for this latest contribution of the Espeys to Chautauquan life.

"I know my eyes aren't what they were," she complained, "but I can't find your name, John. Are you sure your crew won?"

"Let me help you, Mother," Father said, taking the paper.

He began to laugh. "Really, John," he said, "you should take care with your handwriting." He handed me the paper. Listed as Number Two oar of the winning junior division crew, I saw someone named "J. Zisspy."

Father explained to Grandmother. "How dreadful!" she said. "It sounds Middle European." Everyone laughed but Aunt Clara. "You mean to say," she demanded, "that the typesetter was so ignorant he couldn't recognize Espey?"

"So it would seem," Mother observed dryly.

Humiliated, I wandered off, avoiding the club since the rowing tests weren't scheduled until Tuesday. At the public dock I rented a rowboat and pulled slowly along shore up to the creek where we'd hidden the black boat. I turned into it and moored under a tree about a hundred feet from the outlet. I sat under the tree and flipped stones into the water. At what I thought must be lunchtime I opened my bag and ate.

Later, I turned the boat and rowed out into the lake, going up the shore until I came to an expanse of lily pads. I let the boat drift into them and looked out over the water. A speedboat went by and I watched the swells from its wake come closer and closer until they rocked my boat and rippled through the lilies.

After a while I pulled out into open water and practiced turning, first using one oar, then both. I tried a racing start. Just as I thought I was doing well I caught a crab with my

starboard oar and almost fell off the fixed seat. My wrists began to ache. I turned back, rowing slowly, well out in the lake so I couldn't be recognized when I passed the club.

Opposite the club landing I was surprised to see all the boats out and a lot of splashing. I steered even farther off shore and made a long slow half circle coming back to the public dock.

At the club office Tuesday morning the secretary said, "Anything special for you?"

"I'm here for the rowing letter tests."

"But that was yesterday," he said.

"It couldn't have been."

"Well, we found we had some free time, so we called out the names and went ahead."

"But that isn't fair! I had my name down."

"Why weren't you there?"

I couldn't answer that. "Are there any letter tests left?"

"One," he said. "It starts in about five minutes."

"What's it in?"

"Track and Field."

"Oh," I said.

"I'm just taking the list out to the examiners now," he said.

"Could I put my name down for it?"

"If you like," he said, "but you haven't been training, have you?"

"Not exactly," I said.

"Well, try it if you want," he said, shrugging.

After printing my name at the end of the list of about twenty others I ran to my locker and changed into shorts, an undershirt, and tennis shoes.

The tests began just as I rushed out onto the field. I stood on the edge of the group, watching each candidate as he set blocks for a racing start, took off with short strides, moved his arms in rhythm, and sprinted down the track. By the time my name was called I had it down pretty well.

I couldn't know until each test was called what it would be.

I could high jump with the scissors kick. I had long legs, and ran the distance laps fairly well. I took the hurdles slowly, hoping that form would be more important than time. I'd never had a discus in my hand before, but at least it went out in the right direction. I was lucky to get the shot out of the circle. Everyone had the option of one bye, and I used mine for the pole vault, which I'd never attempted. By noon the outdoor tests had ended.

"Now," the senior examiner said, looking at his score sheets, "in half an hour, after you've eaten lunch, we'll go into Room A and you'll take the written part."

Everyone else groaned aloud. I groaned inwardly. What could I do with a written exam in a letter field I hadn't had a single class in?

I took my lunch up the creek and ate it alone, thinking of Ralph caddying for his father and of how we'd never said goodbye or exchanged addresses.

In Room A I sat at a desk furnished with pencil and paper. The senior examiner went to the blackboard and printed: WRITE AN ESSAY ON THE EFFECTS OF TOBACCO AND ALCOHOL ON THE HUMAN BODY AND HOW THEY INFLUENCE ATHLETIC ACHIEVEMENT (One hour).

I gazed with unbelieving eyes.

Then, as my fellow candidates looked at the ceiling, moaned, chewed their pencils—three of them simply gave up and walked out—I grabbed my own pencil and started to write, taking care to make my longhand as legible as possible. I covered page after page with the evangelical rhetoric I knew the subject demanded and that I had heard endlessly all my conscious life. I quoted statistics. I described in detail the ghastly effects of dripping raw alcohol on slivers of human liver. I shuddered over carbon-lined lungs. I cited Holy Writ. I trembled at the prospect of brain rot and impotence, the profaning of God's earthly temple.

I went to the front of the room to ask the junior assistant in charge for more paper and to sharpen my pencil. Around me, sturdy athletes sweated, staring into the middle distance with glazed eyes as they clutched their forelocks and tackled what I suspected would be another sentence fragment.

Near the end of the hour I came through with a splendid peroration that wedded the Protestant work ethic with the Classic ideal. As the others tottered up, drenched, to hand in their three or four smudged pages, I submitted my monograph-length manuscript with a medium Chinese bow from the waist.

The assistant said, "You don't have to turn in the paper you haven't used."

"Thank you, sir," I said, bowing again. "I believe you'll find all the pages written on."

"Yeah?" he asked, leafing through them.

"Yes, sir," I said. "And would you be good enough to tell me when the results will be announced?"

"Oh, we'll probably post the list tomorrow morning—say between nine and ten."

"Thank you, sir," I said.

"That's okay," he said as he scooped up the papers.

I walked out by the swimming pool, wondering if it would be worthwhile taking a dip. I decided against that and wandered up the creek, remembering a long way around through the woods that would bring me out near the border of the grounds, where I could cut across to the cottage.

Once among the trees I loitered. After a while I began to smell skunk. The scent grew stronger and stronger and then faded. I turned back and stepped into the woods carefully. About thirty feet from the path I found the black and white striped furred body stretched out. I couldn't see any marks on it, but a column of ants was already at work. I wondered if it would be possible to skin it without having the smell on the fur. I decided it wouldn't, and anyway I had no knife with me and I'd never skinned an animal in my life. I had no idea how long I stood there looking at the dead skunk and the ant column, not thinking about anything in particular.

When I got back to the trail I wandered on, crossing the upper part of the creek on stepping stones and working my way near the edge of the grounds to Vincent Avenue.

No one paid any attention when I came in and went to wash up for supper.

The next morning I took off early and got to the club just as it opened. I kept busy around my locker until I saw the senior Track and Field examiner going to the bulletin board with a sheet of paper. I waited until he got back inside the office before I sauntered over to the board.

There it was: "Letters Awarded for Track and Field"—and yes, there it was indeed, correctly spelled and in its proper place alphabetically among a dozen other names—"John Espey."

I wanted to leap up or weep or laugh, but I knew with my Presbyterian reserve that nothing like that would do. Perhaps the senior examiner had been watching me, for he suddenly stood there. "You know," he said, "your track and field marks were uneven, really touch and go, but that essay— simply splendid!"

"Oh, thank you, sir."

"Anyway, congratulations," he said, offering his hand. "It was quite an achievement, considering you never took any of the required classes. But we just couldn't fail that essay!"

I strolled back through the town square. At the post office I checked our family box and took out the mail.

Grandmother looked up in surprise from her swing seat on the porch as I came up the walk.

Father sat in a wicker chair beside her, reading *The Chautauquan*. "Why back so early?" he asked.

"Oh, everything's pretty well finished for the season."

He looked at his paper. "I see they're having the letter award ceremony tomorrow night," he remarked.

"I guess that's right."

"I suppose some of your friends will be getting letters?"

"No," I said. "Ralph Trevor didn't try for one, but of course I ought to go. That's just simple politeness, isn't it?"

"Oh, you needn't carry things *that* far," he said.

"You don't need to go if you don't want to," I said. "It will probably be crowded and take quite a while."

He looked puzzled, but then he asked, "Are *you* getting a C.B.C. letter, John?"

"Wasn't that the main idea in my joining the club?"

"Well, yes," he said, "but ... " and he stopped before

going on. "You did say something once about trying for the rowing letter."

"They couldn't even spell the name," Grandmother put in.

"It wasn't rowing," I said. "I finally decided to take my letter in Track and Field."

"Track and Field! But you never mentioned working out for that."

"I didn't really," I admitted. "I guess I have a kind of inherited aptitude from you."

"Well I never!" Father exclaimed.

Mother came through the door. I wondered how much she had heard. "That's wonderful, John, simply wonderful," she said, hugging me. "Of course we'll be there, though I doubt that your grandmother will want to go out in the evening."

"I do hope they've spelled it right," Grandmother said.

"I printed it this time," I said.

The hall was jammed with parents and club members. The senior examiner even pronounced my name correctly. Afterwards we went down to the ice cream parlor near the post office and Aunt Clara stood us chocolate sundaes.

No, I hadn't lied to Coach Pipal. I *had* been through it all. I was already, even as I am now, and as Father was before me, a C.B.C. letterman—Track and Field '22.

Playing the Game

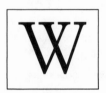HEREAS FATHER STOOD FIVE-eight, well-muscled and compactly built, I was a stringy kid, given to asthmatic attacks, and though I finally reached six-two, I was a skeletal six-footer for years. And whereas Father was a strong swimmer and diver, an enthusiastic player of volleyball, and for a time a crack marksman with the American Company of the Shanghai Volunteer Corps, I disliked diving and never developed any enthusiasm for target or skeet shooting. Father had played on his college basketball and tennis teams, and he kept up his tennis during summers. In different circumstances he might have held national amateur rank.

I early realized how badly I let him down, but long before my surprise achievement in Chautauqua, I had found one spark of hope that I did my best to fan into flame. Skinny as I was, I wasn't clumsy. Later, in school, I had to take part in contact sports and I loathed them all, but I had begun to swing a tennis racket at the age of four and showed some talent for this. Our front verandah in Shanghai ended in a wall with a decorative stripe of red bricks across the gray ones of the house at almost the exact height of a tennis net. I spent hours banging a ball against the brick, sometimes letting it bounce on the return, sometimes trying to go in for a volley. Well above the red line came a shuttered window of Father's study. If I hit it, the wood gave off a crashing pop, and when Father was at home I knew he was both annoyed by this, but also pleased that I was out there practicing. The whole set-up made for hitting the ball low over the net.

Sometimes, when I had smashed the ball into the shutters two or three times, and knowing that Father's patience was being tried, I would go out into the large oval of lawn in front of the house with my supply of worn balls and work on my serve. To the south, the yard ended in a wall covered with Virginia creeper and topped by glass shards, separating our part of the compound from a Chinese cemetery. I would picture a net and service court in my mind and serve ball after ball down the lawn.

Once I had exhausted my supply of tennis balls I crossed the lawn and gathered them in. I couldn't serve back in the other direction, for that would have threatened the windows of the double house for single ladies. So I stuffed my pockets, balanced some balls on my racket, held a couple in my left hand, and walked back to my starting point. Again I pictured

a net, and this time the other service court and went on practicing. From time to time a servant or a mission member might walk through the compound. Sometimes I drew encouraging remarks on how Teddy Roosevelt had overcome *his* boyhood handicaps, and that there was always hope—not to mention prayer.

Father first took me out onto a court when I was not quite six years old. We summered in a mountain resort called Mokanshan and would walk to the tennis courts early in the morning. Father patted or lobbed balls to me and I did my best to return them. From the start we were both surprised by what I could handle. My backhand was weak and uncertain, but my forehand wasn't bad, and I could sometimes come up and hit a sharp cross-court drive or a chop, popular in those days when the tactic of getting into a net game was only beginning to become popular. Later in the day, after lunch, I would hang around and shag balls or play with the older boys on the outer courts if they were free.

After three weeks of this, one afternoon Father and two of his friends, the Rev. Messrs. Montgomery and Snider, found themselves without their fourth, the Rev. Mr. Carter, when the court they had reserved fell free. I was surprised and proud to hear Father say, "I know John is very young and hasn't much experience, but he could play with me until Carter arrives. We could loosen up and it would give him some feeling for the game."

The others smiled and Mr. Montgomery said, "Well, all right, Espey, it might be amusing." Mr. Snider chimed in, saying, "Let's just start playing a game without warming up, because it will be just a warm-up anyway, so why don't you gentlemen"—and he bowed formally but not at

all maliciously in my direction—"take the first service?"

"Fine," Father said. "I'll serve first, John, and you take the net. If you miss a shot I'll try to cover the backcourt."

Father never took anything casually. He had run off two sets of mimeographed sheets, one showing the singles court, the other the doubles. He would sit down with these and "serve" the ball, calculate the possible angle of return, diagram what he thought would be the best way to anticipate that and the possible shots with which to answer *that*. He often showed me these, so I understood what he wanted. At the same time I felt self-conscious in my khaki shorts and short-sleeved striped shirt, knowing how skinny my tanned arms and legs looked. Father and his friends in their white duck trousers and white sports shirts looked like giants.

Father's first serve went into the far corner of the service court, a clear ace as Mr. Montgomery lunged at it. Father and I shifted. He faulted, and his second serve came back in a low drive near the center of the net, where I managed to get the wood of my racket on it, making it kick off on our side. I felt silly and said, "I'm sorry, Father," but he said, "You reached the ball, John. That's good. You'll be getting one over before you know it."

Father's next serve was returned. I couldn't reach it, but Father was ready in the back court and put up a deep high lob, calling out, "Come back, John, while I take the net." Either our shift or Father's calling distracted our opponents, and for a moment it wasn't clear which one would make the return. The lob hit about six inches within the baseline, bounced high, and Mr. Snider, whose forehand it was on, miscalculated and drove it into the net.

Then Father scorched through with another ace. With the

score now at 40-15 he missed his first serve, but placed his
second, which was returned almost directly at me. I got my
racket up and tilted, not thinking about anything but hoping
to return the ball. It angled off so sharply into the opposite
alley that it was unreachable.

"Oh, well done, John!" Father said. "That was the best
possible angle of return, as you must have remembered." I
had no idea if he really thought I had had time to work
this out or not. Our opponents came through with "Prettily
done, young man!" and "He's his father's son, after all."
I wasn't too happy about the "after all," and I felt that
though the formal compliments were sincere enough they
contained little Christian charity.

At first Mr. Montgomery eased up on his serves to me.
I could get back about every other shot, and then it was a
gamble, Father sometimes going to the net, sometimes stay-
ing back. My weak backhand became obvious, and though
we carried the game to deuce we lost it.

On my own service, I found that instead of looking at
the court I saw the lawn at home, the cemetery wall covered
with Virginia creeper. I usually got my first serve in, but there
wasn't much power behind it. Father, however, was quick
at the net, and after we had reached deuce twice we took
the game.

Mr. Snider held service easily.

With the games at 2-all and Father serving, something
began to happen. The returns came back hard. Father got
his first serve in most of the time, and if I moved to the
center of the court and play continued, the ball came to my
backhand. Father ran around me a couple of times, made
brilliant returns, and we pulled the game out.

We led 3-2, and this time around no one was holding up on service or returns to me. The men—for I was too timid—still called out the ritual "Splendid shot, old man!" and "Nice try!" but from time to time line calls were disputed in the most amiable language spoken by crackling voices, and a point would be replayed. My backhand took a terrible pounding. Father played all over the court.

As I started to serve for the second time, with the score tied at 3-all, Mr. Carter arrived, carrying two rackets. "Ah, Carter, there you are," Mr. Snider called out, and Father said, "That's all for this time, I guess, John, but you played very well."

"Thank you, Father," I said. "I know you did most of the work, but it was fun."

"You got in some excellent shots," he said, "and I could see you were remembering the diagrams."

This was no time to say that I hadn't had a diagram in my head, that I'd been scrambling around as well as I could. Nor could I say that it had been anything more than just fun. I suspected that it hadn't been just fun for Father, and it certainly hadn't been just fun for our opponents. They both complimented me as I left the court, but I could tell how relieved they were by Mr. Carter's arrival.

The four men spun rackets for pairing off. Father and Mr. Snider turned up partners, and then won the choice of service or court. They chose service, with Father serving into the sun but not being bothered by it. I knew who would win so I wandered off with my racket towards our cottage.

At home, when Mother asked, "Did you and your father get to practice?" I said, "I played in a real match for a while with Father as partner against Mr. Montgomery and Mr.

Snider. It was just because Mr. Carter came late, but of course Father's so good that we kept it even."

"How exciting it must have been for you to play with the men!"

"I guess so," I said and went to wash up.

And that was the trouble. It had been fun, but whereas the others had found it more than that, I hadn't. I knew that I should have, and I knew I couldn't tell Father that I hadn't.

After that summer, Father never let me forget tennis. He encouraged me to slam the ball against the end of the verandah and to practice my serve on the lawn. The mimeographed sheets appeared and I would be asked about the angle of return, the possibility of getting off drop shots from certain positions, and told repeatedly the importance of having a reliable backhand. Once Father said, "The way to think of the backhand is to remember that cavalrymen of the old school always considered the sabre slash from left to right their most powerful stroke. You could take a man's head off."

Father had resigned from the American Company of the Shanghai Volunteer Corps long before this because he had doubts about a man of peace serving in a private—or, for that matter, a public—army. His military comparison dazed me. I couldn't think of a thing to say except, "Yes, I'm sure, Father."

He went on, "Think of your backhand as a level sabre stroke while you practice it. It ought to help."

"I'll try," I said. But whenever I did, I almost collapsed laughing, seeing myself, scrawny and thin-armed, up on a white charger, making level backhands with my racket at the

neck of some moustached, Teutonic, spike-helmeted enemy on a black stallion. Even so, my backhand improved.

At the start of my junior year in high school Father asked me about the tennis team. "Do you think of trying out for it?"

"Maybe next year," I said. "I play at school, you know, and I can take some of the team members sometimes."

The summer of my junior year we spent in Tsingtao on the north China coast. At the tennis club I now played not only with my own age group but I could make a more than respectable fourth in any combination of doubles. At my very best I could even give Father a serious game.

The morning the tournament lists were posted for signatures I ignored them and went back to the house for lunch not thinking of tennis. I had been assistant editor of the school paper, *The S.A.S. Nooze,* my junior year and would be editor-in-chief the coming year. I had begun work on my first editorial, tentatively titled CRITIX CRAX in the jargon of the day, a presumably witty invitation to criticism and suggestions for improvement.

As I came into the living room Father said, "I understood the tournament lists were to go up today."

"I guess I saw them, but I didn't really look," I said. "I know you're going back to Shanghai early and won't enter. I could put myself down for the junior singles. If I went in for the men's I might manage a round or two with luck."

"I understood they're reviving the old father-son title this year," he said.

"Oh? I hadn't heard that."

"I'll go back with you after we've eaten," Father said, "and we can check it together. That would be a much shorter

list than the others and the finals should come before I have
to go back to Shanghai."

"Fine," I said. "Maybe you could give me some shots to
my backhand if there's a court free. I'm doing something
wrong. I get plenty of swing but they angle out. Maybe it's
my grip."

He went right past that, saying, "There would be the
Walkers, the Carters, the Creightons, the Littles, and a few
other father-son teams. I mention those because they're the
strongest Americans, but—and I wouldn't want to boast—
Deo Volente, we shouldn't have much trouble. That German
pair, the Lockners, aren't bad, but they don't play the net.
As to the English, none of them seems threatening but the
Chesters. They're both tricky, you know, playing the chop
and drop shots well, and they sometimes go to the net, but
not consistently. Neither one of them quite senses the possible
angles of returns, so they can be pulled out of position and
passed down the alley or stopped by a sharp cross-court drive."

As Father poured out all this detail I knew he must have
been making notes all summer. Billy Chester and I played
together fairly often. As an English youth of sixteen he felt
self-conscious at the club because he was well beyond the
age that the English usually sent their sons back to one of
the correct public schools. Why he was kept in China I didn't
know and couldn't ask, but I knew he was grateful whenever
I asked him to play either doubles with friends of mine or
singles if we were alone. "Thank you so much, Espey," he
would say. "I'd be delighted."

I came out of this in time to say to Father, "Billy Chester
and I are fairly even, though I usually win because I have
a better sense of tactics, thanks to you."

Father still wasn't hearing me. "There's an odd thing about the senior Chester that I may as well alert you to now, since your mother must be in the kitchen or upstairs writing letters."

"Yes?" I had no idea what was coming.

Father cleared his throat. "I'm sure you remember that time in Kuling when you were playing the net and the ball— what shall I say?—took you and you went to your knees?"

I laughed and said, "Could I ever forget it?" We lived in an innocent age. No one thought a jockstrap—"athletic supporter" in our public vocabulary—necessary for an adolescent boy playing tennis. That return had taken me full in the crotch and I had gone down on my bare knees, crippled by unbelievable tides of pain. Somehow, I got to my feet. Everyone knew what had happened, but it couldn't be acknowledged. "You all right?" my partner asked. "In a minute or two," I said. I risked a step. I played out the set shaky and sore, missing returns (but not, I hoped, too deliberately) until I could walk off the court with head up and legs not all that far apart.

"It may strike you as an unusual thing to have noticed, but any return toward the center of Mr. Chester's body— *confuses* him. He protects himself with his racket without any thought of a possible return."

"It's perfectly fair," I said. "You're just returning the ball to the most effective area." I hadn't meant it as a joke, but as I heard myself I began to laugh.

"I'm glad you agree, but I'm not sure it's particularly funny. Seriously, I'd like to have us win that title."

"I would too, Father," I said, trying to keep from losing control, gasping and recalling the pain that had felled me.

"Really, John," Father began, "there are times when I don't understand . . . " and then Mother came in from the back of the house, saying, "We're having a light lunch, and, John, if you are going back to the courts with your father you don't need to change, but you really should wash up."

"Yes, Mother," I said, and as I went to my room I heard Father saying, "There are times, Mary, when I think the influence of your family . . . " and I knew Mother could take it from there.

At the club, Father found the right sheet and signed us in with his beautifully controlled longhand, the capitals written with a minimal flourish, but still a flourish.

As if fated, the Chesters showed up in the top bracket, the Espeys in the bottom. I saw from the beginning that Father put all his energy and skill into our matches and began to understand the tournament's importance to him. If we could come through with the championship he felt it would give me confidence. I would make the team in Shanghai and have enough impetus to carry on with the game in college in America. In short, I would deserve to be his son, though neither of us would have put it that bluntly at the time.

Between matches, I polished the elegant periods of *CRITIX CRAX* and planned a reorganization of the *Nooze* and its monthly illustrated magazine. On the courts, I played what I knew was my best. I shifted my grip for the backhand; I enjoyed the feel of my first lightweight ankle-length white flannels as well as the secure intimacy of my first jockstrap.

We played the Chesters in the finals early on a Friday afternoon before a modest gallery. The Lockners, whom Father and I had knocked out in the first round, stayed away. The Chesters had handled the Walkers easily enough, and

the Walkers, Episcopalians, knew that courtesy required their presence. This was also true of the Creightons, Presbyterians, whom we'd met in the third round, during which the Chesters had put away the Littles. Mrs. Little had been one of Mother's students years before at Miss Jewell's School in Shanghai, and she sat with Mother. Others drifted in as we and the Chesters warmed up. We had an umpire in a chair at the net, but line and service calls that he couldn't make were left to the gentlemanly instincts of the players.

The Chesters won the spin of the racket and chose to receive in the sun. "Shrewd enough," Father said. I took the first service and held, Father playing well at the net. After we changed sides Billy served and the Chesters held.

Then Father double-faulted. His next serve shot completely out of control. His second one came over weakly, to be angled off by Mr. Chester with a stinging chop stroke completely out of reach. With the score at love-30 I knew we were in trouble. Just how much I felt only when Father's next serve took me in the back, above my right kidney. I had been crouched and the ball skidded up and over me out of play. A slight sound—surely nothing so impolite as a snicker—came from the gallery. Father's second serve was another pat shot, but Billy hit it almost straight at me and I put it away with a volley that caught Mr. Chester flat-footed.

Had Father's next serve been clearly fair we might have been all right, but the umpire, after hesitating, called it a fault.

"I beg your pardon, sir," Mr. Chester said with impoverished imperial dignity, "but I do believe the Reverend Mr. Espey's serve was fair. Your not too instant call confused me.

I suggest we replay the point, with Mr. Espey given two serves." We bowed all around as the umpire yielded.

I didn't know Mr. Chester at all well, but I understood what he was up to. Father, with his standards of sportsmanship, had to throw the point, but not obviously. He sent his first serve six inches below the top of the net. Even so, he came close to hitting my left hip. He angled out his second serve, but much too far out, and I knew he was baffled.

At 15-40 Father missed his first serve to Billy, then sent in his second serve a little stronger than usual. Billy put up a weak lob over me, and Father, coming in for a certain smash, put it solidly into the net. For the first time in the tournament Father had not held service.

I knew that Father had tied up. The finals were scheduled for the regulation three out of five sets. During the first set Father never recovered control and we lost it. I had never given Father an order in my life, but as we started the second set I said, "What would you think if you went to the net, Father, as often as possible and let me scramble over the backcourt?"

"All right," he said. "Really, I can't understand. . . . "

"Don't worry," I said with false confidence. "You're just a little overeager, and you'll loosen up soon."

The Chesters played steadily, with an infuriating lack of flair. Father was good at the net, and I took the passing shots, cruising from one side of the backcourt to the other, panting, drenched in sweat. Somehow we pulled out the second set.

But then things began to come apart. I was exhausted, Father was confused. Mr. Chester made a couple of his humble suggestions to the umpire whenever it looked as if Father might be settling down. Father hit me in the back

again. I took over, shouting, "Up, Father!" or "Back, Father!" or "Leave it for me!"

I began to loathe the Chesters. For the first time in my life I truly wanted to win—not for the title, not for me and my future career in tennis, but for Father. I made impossible saves. Too late, I remembered Father's remark about Mr. Chester's "weakness," and every chance I had I drove the ball straight at him. Mr. Chester simply covered himself with his racket, and the closer the shot came to his crotch the more desperate his automatic move. I still believe that if I had thought of this earlier and if Father had loosened up just a bit the result might have been different. But I couldn't return every shot to Mr. Chester, and unluckily my concentration on CRITIX CRAX began to betray me. I heard my inner voice playing with words that arranged themselves into "Chip a chop to Chester's crotch!"

I wish I could record our brilliant recovery, with Father pulling himself out of his slump, placing ace after ace, and with me finally unmanning Mr. Chester. It didn't happen, though my blood was up. I would have murdered to win for Father. But then I would think of my line and comedy would break in. We took only the second set.

At the end, Father and I ran to the net, reaching it ahead of the Chesters and hurdling it, holding out our hands, saying "Very well played!" and all the other formulas. We outpointed them on that, at least.

Walking back with Mother to the house for a late tea we said nothing at first. Finally she ventured, "You played well, John, you really showed you could cover the court."

"I don't know what happened," Father said, his voice shaky. "After that first double-fault, I wasn't myself."

"It wasn't anything," I said. "We were unlucky enough to have an off day."

"*I* had an off day," Father said, his voice firm now. "You were splendid, John. Some of those saves I couldn't believe. I could see you using the diagrams and later—ah, well—Mr. Chester's weakness."

"I was surprised myself," I said. I wanted to go on and say that I had made those saves only for him, that losing the championship worried me less than nothing. I wanted to recite "Chip a chop to Chester's crotch" and try adding a few lines to it—"botch" sounded like an appropriate rhyme. I had already lost my insane hatred of Billy and his father. But of course I couldn't say any of this, which would have truly shocked Father, and I came out lamely with, "We reached the finals, anyway, Dad," risking that intimate title that Mother and Father had told me was no longer appropriate when I turned twelve.

Father looked up at me. We belonged to a tradition that made it impossible for a male to weep, but I saw the tears in his eyes as he said, "Yes, we did that."

"And we both know that on an average day we're better than the Chesters, especially if we should concentrate on Mr. Chester's weakness."

"That's true," Father said.

"Whatever are you two going on about?" Mother demanded. "You know you had a bad day, but you did the best you could. And what is this mysterious *weakness* of Mr. Chester's? Poppy Little began to laugh so much during the last set when John was running all over the court that I was afraid she might go into hysterics. I thought John should have hit the ball to Billy more often, but he kept sending it to

Mr. Chester, and it's true it usually didn't come back. I asked Poppy what was so amusing, but she wiped her eyes and giggled out 'Oh, Mrs. Espey, I really couldn't say!' "

Father's eyes had cleared and we exchanged a knowing, masculine glance. "It's really nothing, Mary," he said, his voice controlled and pulpit-smooth. "Really too technical for you since you don't play. I'd picked up a slight weakness of Mr. Chester's game and John cleverly took advantage of it."

As we went through the front door and into the hall, Mother headed directly for the back of the house, saying she wanted to be sure the servants had everything ready for tea.

After Father and I stored our rackets in the hall closet he began, "John, I don't know what to say . . . " and I interrupted with "Nothing, Father, nothing," knowing that I couldn't risk another "Dad." "You tied up. Everyone ties up sometime." This was only a sort of Platonic truth for me; I had never tied up because I'd never cared that much until then.

"I had so much hoped . . . " Father began again.

"I know," I said, "and don't worry. I'll go out for the team when we get back. Scott Crawford's sure to be the captain, and we're roommates. He doesn't know how well I can play if I put my mind to it, and he's never studied the game the way we have—the diagrams and all that. He plays instinctively and he's heavy and tall for his age and has some great strokes, but he's not all that savvy."

And there was Mother, back from the kitchen, saying, "There's plenty of time to talk later. Why aren't you already changing? Off to the showers, as they say at the YMCA!"

Father and I goggled. "I thought that might surprise you," Mother said, "and it occurs to me that if I thought it worth putting my mind to, I might uncover the reason Poppy Little came so close to hysterics."

Father and I were in full flight as she finished her sentence. We sluiced off in the upstairs bathroom, modestly standing back to back. In my own room I changed into white shorts, a boy again, and a blue-and-white striped linen sports shirt. Father came down a few moments after me, dressed in impeccable whites and a long-sleeved shirt with an almost invisible black pinstripe, open at the collar.

Mother said, "You both look almost civilized again. I'd thought of having a sitdown tea in the dining room, but I think it's more comfortable here in the sitting room with the teapoys. Everything can be cared for in the kitchen and carried in."

When our teacups, saucers, and plates were served us, I understood this change of plan. Something drastic had happened to the frosting of the already sliced cake wedges. Instead of being smooth, it had been swirled into a multi-colored sort of fudge, showing the marks of a hasty revision. I glanced at Mother, my eyebrows up, and she nodded back. She had obviously planned a victory celebration and an inscription had had to be obliterated at the last minute.

Father took a swig of tea and a bite of cake. "Ah, devil's food! Always my favorite." Mother smiled at me. We had almost left the tournament behind us.

Back at school in Shanghai I spoke to my roommate Scott about the tennis team. "I know I'm not as hefty as some of the others," I said, "but I haven't a bad sense of tactics."

I entered the try-out games and they went well. When the

first issue of the *Nooze* appeared under my editorship it carried *CRITIX CRAX*. I took a copy home over the weekend and left it on Father's desk.

At dinner Father said, "I'd forgotten, I'm afraid, that you're editor of the *Nooze* this year. That is, in its own journalistic way, an entertaining editorial, and I like the title."

"Thank you," I said.

"I wanted to ask who gave it to you."

"Gave me what?"

"That catchy title."

"Nobody gave it to me," I said. "I thought it up myself in Tsingtao."

"Indeed?" he asked.

"Indeed," I said, hurt, knowing that when he used that word he hadn't quite believed me.

"It's very good." I could see Mother signaling desperately at him from her end of the table, but Father was blind and went right on. "You must have a good faculty adviser this year. That editorial is really well written, especially for a high-school paper, and so is the rest of the issue."

"I'm glad you think so," I said. "I wrote every word of the editorial myself and much of the rest. I'm just getting my staff organized and the adviser had nothing to do with any of it, having just been appointed."

"You mean no one at all helped you with *CRITIX CRAX?*" Father asked, spooning up his chowder.

"That is exactly what I mean."

"I must say I'm surprised," Father answered.

Before I could speak Mother cut in with, "It doesn't surprise me at all, Morton. You know your sister Clara has

published three books and may be working on another. You yourself aren't illiterate, and when I presented my senior thesis at Madison, some of my professors insisted that it was worth a Master's."

"Of course, my dear," Father said.

I went back to school the next day, Saturday, using the *Nooze* as an excuse. That night I knew I had an attack of asthma coming on. I spoke to Scott. "Listen, I'm coming down with one of my rotten attacks. I can keep up the classes and I've got to look after the *Nooze*. But I can't get out on the courts, and I know you want to make up your final list by the end of this week. Just forget about me."

"But you're good, John," Scott said generously. "You've got some terrific cross-court shots and a solid backhand. I don't know how you do it, but you keep pulling some of us stronger guys out of position and you always have a reason for coming to the net."

"Yeah, well. . . . "

"You wouldn't always be in the first four, but often enough, what with doubles, to get your letter."

"No," I said, my breathing growing more and more difficult. "It wouldn't be fair to the others, and really—well, right now . . . " I had planned to say "I don't care," but I could no more say that to Scott, a dedicated athlete, than I could to Father.

I stayed at school the next weekend, wheezing and working on the paper. My next Friday night at home Father said, "I'm sorry you're having asthma again."

"It's not too bad by now," I said, "but I couldn't go on with the tennis try-outs."

"I'm sorry about that, too," he said, and I knew he was.

"How is the *Nooze* going?"

"All right, I guess."

"Have you brought home copies of the new issues?"

"I'm afraid I left in something of a hurry," I said.

"I'd be interested in seeing them."

"I'll try to remember next time."

Mother came downstairs and we went in to dinner.

At college in Los Angeles and later at Oxford I played tennis socially in superbly tailored white flannels. After my parents had been forced to leave Shanghai under gunfire and had retired to Pasadena, my wife and I ate with them once a week. Years had passed since the Tsingtao fiasco, but neither Father nor I had ever mentioned it. He had to use crutches now. A college friend gave me a pair of tickets to the Southwest Tennis Tournament one season and I asked Father if he'd like to go, saying that with my friend's membership pass I could park in the club lot, making it easier for him, and that I thought he would enjoy it.

He did. During the men's singles final after a particularly stunning rally he turned to me smiling and said, "That was exactly our Singles Diagram Five, wasn't it?"

"Absolutely," I said with all the enthusiasm I could put into my voice. Singles Diagram Five! I couldn't have given him One or Two.

After dinner in Pasadena that night I knew he was thinking about Tsingtao. I said, "You were a terrific tennis teacher, Dad."

He looked startled. "I guess I wasn't too bad, but since you've brought it up I may as well say that I've always wished you had taken the game more seriously, both at college and after."

"I know," I said, "but there were other things that seemed more important. And anyway, I could never have been as good a player as you were at your peak."

"Oh, I don't know," he said. "You're six inches taller than I, I'm happy to say, and that would have made a difference." But I suspected that within himself he agreed with what I had said, though I didn't necessarily agree with it myself.

"I still can't understand why I tied up at the worst possible time back there in Tsingtao," he said. "And you—you played brilliantly."

"It was nothing, Father," I said. When I had opened this exchange I had thought that at last I could tell him it hadn't mattered to me, that I'd have enjoyed beating the Chesters, but I hadn't honestly cared for more than a few crazy minutes and that I'd played as I had only for love of him. It made sense, I thought at first, to say this. But then I understood that to say it even now would be more shocking to Father than anything else I could say. So I shook my head, saying, "No, I could never have been the player you were, Dad."

Mother came cautiously into the sitting room and we exchanged the merest of nods as Father smiled into the past.

Even Comedy Must End

DURING THE SUMMER OF 1935 after I had graduated from Occidental College in Los Angeles, I crossed the Pacific to China, where I spent the holidays with my parents, my sister, and my brother-in-law at Peitaiho, a northern summer resort. Early in the autumn we all returned to Shanghai, and shortly after our arrival I boarded an Italian liner that put in at Hong Kong, Singapore, Colombo, and Bombay before going through the Suez Canal and on to Venice. From Italy I would go through Switzerland and France on my way to Oxford, thanks to my luck at having won a Rhodes Scholarship.

I enjoyed a Grand Imperial Tour because two of my cabinmates were young Englishmen, whom I shall call Peter and Paul Finchley—Peter, a recent Cambridge graduate in medicine, Paul still an undergraduate at Oxford. I had met the Finchleys, whose parents were casual friends of my parents, during the summer. We sailed out of Shanghai and reached the mouth of the Yangtze after sundown. The fourth tourist-class traveler in our cabin, a Middle-European businessman several years our elder, spoke English with a slight accent. As we prepared for dinner he produced a bottle of Russian vodka and said, "I hope you gentlemen will join me in a drink." He reached for the tumblers above the washstand and filled all four.

At the age of twenty-two I was not a particularly experienced drinker. During my four college years, the first two under Prohibition, I had visited speakeasies and drunk a variety of bootleg alcohol. After the Repeal I put down an occasional legal glass of wine, beer, or hard liquor. Vodka, however, I was unfamiliar with except by name. The colorless liquid looked harmless enough. We all clanked our heavy glasses. Peter Finchley proposed "To a good voyage!" and we drank. The vodka slid smoothly down my throat. Before long I had drained my glass. Our cabinmate emptied his a little later, excusing himself, saying he wanted to find his place in the dining saloon before it became crowded.

The Finchleys, I now suspect, were more familiar with vodka than I, for they did not finish their drinks, putting them back above the washbasin after a few swallows. Peter suggested that we too find our seating, and went out ahead of me. With my middle-class American concern for doing the correct thing as well as the bravado of an adopted Westerner

and Californian, I gulped down what was left in their glasses, thinking that our cabinmate might be offended on returning to find his offering undrunk, and hurried out to catch up with the Finchleys.

As we reached the dining saloon, where we found a table assigned to just the three of us, I began to wonder if I hadn't made a mistake. Not only was I ravenously hungry, I was just able to manage my chair without, I hoped, showing that the vodka had taken hold of me. The Finchleys were flushed a little themselves, but we all ordered our dinners without difficulty.

Worse was to follow. Shortly after the steward had left I found myself totally sightless. For a few seconds terror and remorse gripped me as I felt my balance dissolving into a side-to-side rocking motion.

A growing hum started and my eyes, if slightly unfocused, began to make out the Finchleys. I knew then that I hadn't gone blind. The ship's power had either been turned off or had failed.

"Thank God!" I said, as the ship continued to roll.

"You all right, John?" Peter asked with medical authority.

"Yes, yes. I'm fine," I said.

"I can't think it's much to be thankful for," Paul put in.

Too embarrassed to explain, I said, "Yes, it was a stupid thing to say."

In a minute or so the lights came on. There we sat amidst the rising chatter of our fellow passengers. Our steward appeared to say that it had been a matter of switching transformers as he served our soup. The ship steadied as the engines came on again and we began to round to the south.

That blackout struck me later as symbolic of almost the

entire voyage. I mistook one thing for another, never quite grasping what I heard and saw. News of the Finchleys' arrival had preceded them, and either their relatives or English friends of their parents met the ship. The Finchleys generously included me in their party, and the three of us were lavishly entertained.

After Hong Kong our social status rose. The ship's doctor had been hospitalized ashore for acute appendicitis, and Peter found himself translated to that office. This meant that he moved into first-class quarters where he could invite Paul and me to visit or dine with him whenever he chose. Meanwhile, our European friend found that he could move into a single cabin—not that he showed any signs of disliking us—so my free source of Russian vodka, for which I was developing a taste, disappeared, probably to everyone's benefit.

In Singapore we were driven about and escorted to a beachside club for luncheon, during which we were assured that in a military sense the colony was impregnable, that heavy armor covered all sea approaches and the impenetrable jungle to the north provided complete safety from invasion. I swallowed it all, including the scotch-and-sodas so appropriate to this setting. I had spent several summers as a boy in Tsingtao, the stronghold of the Kaiser's very late imperial venture in the Orient, and had played in the ruined forts and gun emplacements facing the sea, making it impossible to turn them half-circle when the Japanese landed up the coast and tastelessly attacked from the rear. Even with this knowledge in the back of my head I felt complete confidence in what our hosts told us.

My vision cleared enough for me to catch a glimpse of one corner of the truth only in Ceylon; for at Colombo our hosts

were not English but two Singhalese, friends from Peter Finchley's Cambridge years. Our meeting proved a trifle stiff all around, with Peter introducing me simply as "Espey" to his friends, whom he called Banda and Premadasa, though the Finchleys and I had long been on a first-name basis. I apologized for making an unexpected third, assuring the two Singhalese that if their plans made it at all difficult to include me they should go right on and let me look after myself, adding that I had even cashed a traveler's check at the bursar's office to meet such a situation.

Premadasa replied smoothly that it made no difference other than increasing the pleasure they looked forward to enjoying with us. I was not born a son of the Orient for nothing. I recognized the instant accommodation and knew I would never discover if my presence inconvenienced them. I thought not, and by nightfall I even felt I had added a little to the day's delights.

We stopped first at Banda's home. I had entered private Chinese homes, but not many, and I appreciated this as the most flattering gesture they could make. Banda introduced us to his mother and three beautiful younger sisters who served us tea and light refreshments. The Finchleys took this as a matter of course, I saw, but I could not. I flirted harmlessly with the oldest of the sisters, speaking in her presence of her beauty and the beauty of her sisters. Their mother understood enough English to know what I was up to and they all giggled, which gave me a chance to bow from my chair to their mother and observe that the source of this beauty was evident. We went through a little scene of more giggling and blushes, and Banda's mother gave me a coquettish glance before she turned her face aside and looked away, continuing to smile.

Up to this time I knew I had given neither of the Finchleys any cause for concern over my manners. But here, where they should be responding to the ultimate compliment of meeting Banda's mother and sisters, they were growing more and more uncomfortable, and I knew I was the chief source of their uneasiness. I understood then that though the Finchleys had both been born in China, nothing of the Orient had rubbed off on them. Like all proper English sons, they must have been shipped back to relatives in England by the time they turned ten, to ensure their going to the right schools before entering one of the two universities that counted.

They were on the point of being embarrassed for me, but as our two hosts smiled and softly exchanged remarks in Singhalese, I knew that it was I who should be feeling uneasy, and about the Finchleys.

Peter said, "It's very interesting, you know, to be in India," as his contribution.

Premadasa murmured, "But of course you are in Ceylon, Finchley," in a neutral tone.

Far from being fazed by this, Peter rode right over it, with, "It gives one a sense of the breadth and influence of all the British holdings."

I had been exchanging formalized shy glances with the older daughter, but I knew that if the conversation went on in this way we would have a difficult day ahead of us, so I dropped my Oriental manners and turned American, saying, "You know, I grew up in Shanghai, and my father discovered an Anglo-Irish family there, distantly related to us through his mother. We exchanged teas and dinners two or three times a year and my so-called cousins used to tell me that the Americans won their little revolutionary war only because the

redcoats didn't want to harm their own brothers, so to speak."

"That's interesting, I'm sure, Espey," Paul said, "but it hasn't much to do with India."

"I think it has," I said, "even though we happen to be in Ceylon, because the time came when my cousins—two boys about my own age—brought out the information that the sun never sets on the British Empire. I knew the answer to that one, which they hadn't heard."

I stopped, holding everyone's attention.

"And what, pray, would that have been?" Paul asked with an edge to his voice, walking right into it.

"Oh, you don't know?" I asked with Chinese innocence, dragging it out as long as I could.

"Certainly not," he said.

"Well," I said, "it's simply, 'Of course the sun never sets on the British Empire because God can't trust it in the dark.' "

Premadasa and Banda kept their faces under fair control, the oldest daughter giggled and stopped, her sisters grinned, and their mother's throat worked hard for a few moments, though her tightly gripped hands betrayed her.

"I don't know that that's so awfully amusing," Peter Finchley said. Turning to his two friends he asked, "What would you, as Indians, say? After all—British justice, British law, you know?"

"I can't speak for an Indian," Banda said, rising, "but for myself I can catch the point, American as it may be."

Premadasa and I stood. Over the heads of the Finchleys, a little slow to respond, the three of us exchanged glances with just the hint of a smile and slightly lifted eyebrows.

On their feet at last, the Finchleys moved toward the door, scarcely acknowledging the women. I felt it would be incorrect for me to offer my hand, but I bowed to Banda's mother, who remained seated, and she smiled. I bowed not quite so low to the two youngest daughters, and a little deeper to the eldest as she stood beside the door, Premadasa and Banda waiting for me to precede them. I decided it would be unsuitable to go through all the Chinese maneuvers of getting through a door without rudeness while retaining correct precedence, so I made only the mildest effort to get them to go before me. When they refused I went on, and as I passed through, the eldest daughter whispered, "Very amusing!" in perfect standard English.

We next stopped for an early luncheon at a Singhalese restaurant. Banda said, "We thought you should sample the food we eat at home. Tonight we'll eat a proper English dinner before your ship sails."

After we were seated both our hosts warned us about the hottest curries. I had a taste for spicy food and was accustomed to curries of some strength, but even so I went cautiously. The Finchleys, not to be outdone, ate bravely, too bravely. The Singhalese and I faced the disturbing sight of two Englishmen weeping in public. They stuck it out bravely, and with the help of many cups of tea and several glasses of mineral water completed their meals in something just a little beneath imperial dignity. Banda and Premadasa showed them out with a display of concern, through which the slightest hint of irony surfaced.

As we strolled along, looking into shop windows, Banda said they planned to take us by hired limousine, stopping once on the way, to Kandy, where we would see at our leisure

the Temple of Buddha's Tooth and its ornamental lake, returning to Colombo by a route that would take us through a number of tea plantations, thus showing us in one day a variety of Ceylon's aspects, ending with a European dinner on the terrace of a waterfront hotel. "It won't, I'm afraid," said Premadasa, "be the *best* dinner of that kind Colombo offers, but it's the best the five of us can expect to eat together."

I couldn't tell if the Finchleys understood this remark. Paul said bluntly, "It sounds a good plan," and Peter nodded.

We were, I felt, letting the Orient down badly so I broke in with, "But it's absurd to let us put you to all this expense— especially the limousine. Since I couldn't have been included in your original plans, I do hope you will let me pay for that. It's the least I can do, and I shan't be comfortable if you don't allow it."

Both Singhalese brightened at this, and Banda said, "But that's quite ridiculous. The payment for the limousine would be exactly the same whether you came with us or not, so it's not in the least logical that you pay for it in any way."

"Oh, but I feel that I should," I said. "I know how disturbing it can be to have one's plans changed, and you would be doing me a courtesy."

One of the Finchleys should have come in at this point, putting forward a compromise. But they walked along, ignoring what they no doubt felt was a foolish quibble.

So Banda had to continue without the obligatory interruption. "You mustn't think of it," he said. "You are a valuable addition to our party. With four persons on any decision, you can deadlock, but with five there must always be a majority."

"Indeed?" I asked, and my voice sounded in my ears like my father's. "What if one of the five were to abstain?"

"Very clever," he said, "and *very* Chinese, I suspect."

"As to that," I said, "I couldn't say for certain, but truly, I'll feel injured if you don't allow me to contribute something."

Premadasa and Banda broke out in splendidly vehement confusion, talking in high voices at the same time, assuring me that this was quite impossible, that *they* would be the injured parties if they permitted such a thing. The Finchleys stood aside, showing they hadn't the slightest intention of paying for the limousine.

Neither had I, for that matter, and I knew that our hosts knew that I hadn't, and that they knew I knew that they knew, and on into infinity.

We had reached the garage. "If you feel that strongly about it," I said, "there's nothing for me to do but yield. It's surely better that I alone feel injured than to bear the responsibility of putting an injury on two others."

Paul Finchley, who was reading Greats at Oxford, snorted at this bit of reasoning, which his education, however correct, hadn't prepared him for, but both Singhalese smiled radiantly and Premadasa even reached out and patted me on the shoulder, saying, "But that removes any injury entirely from you, as well as from us, you know," and the three non-Finchleys, to put it in terms that Greats prepares one to accept as truth—not a truth that would ever get by in the Orient—laughed together.

I thought I might have proved a slight strain, for the limousine was chauffeur-driven, requiring Premadasa to sit in front with Paul, and Banda on the back seat between Peter and me. I sat directly behind the chauffeur and thought of going through the gesture of pulling down one of the jump

seats and trying to sit on it, thus riding backwards, which would have required Banda to try to trade with me and another exchange of courtesies before we all ended up exactly as we were. But I decided we had observed a sufficiency of conventions, and the Finchleys might show impatience, the ultimate rudeness. So I leaned back with an inner glow of Chinese superiority.

We rode through a green countryside, and slowed down for a small village. Beyond it two elephants carried pieces of lumber. In the next village a sign in English read "Join the Y.M.B.A."

"Now just what would that be?" Paul asked from the front seat.

"The Young Men's Buddhist Association," I said before anyone else could answer.

"How very funny!" Peter said.

"Only if you happen to think the Y.M.C.A. is funny," I said, "which, as a matter of fact, I do."

Premadasa and Banda stared straight ahead.

Our one stop proved to be at a small, private zoo on a Singhalese landholder's estate. An attendant showed us through an area something less than an acre in size. We looked at the animals, the attendant would say a few words, and either Banda or Premadasa translated. At a cage containing a king cobra the attendant beat against the screening with a stick until the snake rose, spread its hood, hissed, and finally struck. The relative slowness, compared with a rattler's strike, surprised me.

Zoos, no matter how well run, depress me. I walked ahead of the group, reaching the limousine before even the chauffeur had returned.

On the road again, Banda asked me, "You are not interested in animals?"

"Oh, I am," I said, "but I've always found their imprisonment disturbing."

"That is a feeling not uncommon here," he said, and I felt he spoke out of more than politeness.

"On the other hand," I said, feeling it was up to me now to take the other side, "it's a convenient way to see the country's fauna."

"You are too kind," he said. "What impressions, if any, did you receive?"

"I'd never seen a cobra before," I answered, "and I was surprised by the relative slowness of its strike. It seems a less menacing snake now than it has been in my imagination ever since reading 'Rikki-Tikki-Tavi' as a boy."

"What an odd name," Paul remarked.

"*The Jungle Book*, you know," Premadasa said.

"Yes, and old Nag," I added.

"But you said the *relative* slowness," Banda insisted. "Relative to what, may I ask?"

"You must have read Jurisprudence at Cambridge," I said laughing.

"Yes," he said, laughing in return.

"Since I'm caught out," I said, "I'll have to confess that I was comparing the cobra's strike with a rattler's."

"Very interesting," he said. "You have seen a rattlesnake strike?"

"Yes," I said.

"And what did you do?" he continued.

"You must be deadly in cross-examination," I said, knowing that I was going to startle the Finchleys and shock both

Banda and Premadasa. "If you must know, I broke its back with a stick and ground in its head with my boot heel."

"Good show!" Peter said from the front seat.

After a slight pause Banda said, "That would not be possible here."

"No, of course not," I said, "but a rattler near a trail or a house, where children might pass or play—it's part of a certain code, not the same as yours, but it carries its own burden."

"I can see that," Banda said, nodding.

"But what odd names," Paul put in, "Rack-Tivvy or whatever and Nag!"

"Not to mention Bagheera," said Premadasa.

"And Kaa," I said. "I always got the shivers at his encounter with the Bandar-log."

"Whatever are you talking about?" Paul asked.

"Kipling," I said. "Rudyard Kipling, the English writer."

"Oh, of course," he said. "But was he really an Englishman? I thought . . . "

"Anglo-Indian, if you wish," I interrupted, "and he married an American woman and lived in America for a time." Out of the corner of my eye I caught the twitch of Banda's lips.

"That's it," Paul said. "That explains it."

Peter turned the conversation to his Cambridge memories of the years that he and Banda and Premadasa had been up together. Every now and then he recalled a party or a London adventure that he alone remembered, but the conversation went smoothly enough as we drove up into the hills to Kandy.

Once there, we looked at the lake before entering the

Temple of Buddha's Tooth, admiring its painted columns and gilded decorations.

"But the tooth?" Peter asked. "Just where is the tooth?"

"It's shown ceremonially once a year," I said, forestalling Banda and Premadasa. "Occasionally truly exalted guests, which we aren't, may be honored."

"How do *you* know about this?" Paul asked skeptically.

"I read a little about Kandy in Lawrence's letters when they came out," I said. "You know, that collection edited by Huxley."

"I thought Lawrence spent most of his time in Arabia," Peter said.

"Oh dear," I said, "that's another Lawrence. This was D.H. Lawrence, the author of *Sons and Lovers*—and *Lady Chatterley's Lover.*"

We had found a few pages of common ground at last.

"Really?" Paul said. "And the writer of *that* book was once here?"

"He was," Banda said, "and made some interesting observations."

"Wasn't the Prince of Wales here for the—I'm embarrassed, but I can't remember the word exactly, and I'm sure I'd mispronounce it," I said.

"Parahera," Banda said. "Yes, the annual celebration. I'm afraid Lawrence called the prince a 'poor little devil.' And he wrote something—valid, I suppose—about the 'barbaric substratum of Buddhism' and the 'boneless suavity' of the Singhalese."

"Not to mention his 'dramatic opposition to everything American,' " I added.

"Certainly Kandy was not, as you say, his cup of tea,"

Premadasa came in. "Sometimes I feel that though he's always praised for catching the spirit of a place he's really catching his own spirit in relation to the foreignness of a new setting. That was true here, surely."

"Most interesting," I said, and wanted to continue. But we saw that we had lost the Finchleys, so after a few more minutes we went outside.

Back in the limousine, we drove through slopes covered with tea plants, and could glimpse here and there a plantation house. We stopped at a roadside rest-house where we drank some tea before returning to Colombo. Under the hot sky it all looked like a Hollywood set for a Somerset Maugham tale of conflict and passion.

Darkness had fallen by the time we reached the hotel where we were to eat not quite the best European food in the city. As we pulled up, I saw my chance, and opened the door on my side, plunging my other hand into my pocket for my moneyclip. When the chauffeur opened his door a moment later, ready to go around the car, I pressed, somewhat ostentatiously, I admit, a generous tip into his hand and said, "I want to thank you for driving us so far and so well."

"Oh, thank *you,* sir," he said. Banda and Premadasa, outwitted, laughed and scolded me.

"You Chinese!" said Banda. "You can never be trusted. And you can understand why you aren't always welcomed with open arms beyond your own borders."

Banda and Premadasa looked at each other in mock dismay, Banda asking, "Is this a display of Chinese or American manners?"

"Who can tell?" Premadasa said, smiling broadly.

If we really ate the second- or third-best European meal to

be obtained in Colombo at that time and in that company, it couldn't have been far off the mark of the very best. We sat on a terrace overlooking the port, where we could see our liner, which would sail at midnight, berthed within easy walking distance.

I had speculated on the genuine religious convictions of Banda and Premadasa. Whatever they were, they didn't exclude alcohol. I asked for vodka over ice the first time around. The others remained correctly outpost-of-empire with either a scotch-and-soda or a gin sling. I signaled our waiter for a second round and insisted on paying.

"We surrender!" Banda said, laughing. "How can you fight against both China and America?"

After champagne with our dinner we relaxed over coffee and liqueurs. Our conversation had wandered over the globe and may not have been altogether consistent or closely reasoned. But after my ventures with Kipling and Lawrence I wanted to ask one final question.

At the next general pause I leaned forward and said, "I know as well as you that Ceylon is not India, but relationships survive. I'd be tremendously interested to know what you—as Singhalese, as sons of your own culture in a way that I'm not truly Chinese except for a trace of surviving influences—think about *A Passage to India?*"

This provoked an immediate response from both Premadasa and Banda, who talked together, each interrupting the other, gesturing freely. They both stopped and laughed and Banda, across the table from me, said, "Oh that dried-up little don! It is quite incredible what he saw, what he understood. You know, all the details, the conflicts, just right. And the love of argument, different views, as it were, of the truth,

and how he hit upon the love of litigation—litigation simply for its own sake."

"I see you chose your profession wisely," I said.

They both ·smiled. Then Peter said, "But what are you talking about? What passage to India—surely through Suez?"

"Well, yes," I said. "But it's a book, a famous novel by Forster."

"Forster?"

"Yes," I answered, with unbelieving ears. "E.M. Forster, Edward Morgan Forster. The book's quite well-known—came out in '24 if memory serves." I heard how artificial my voice sounded.

"Quite," said Premadasa. "Truly an amazing insight, and all the more so coming from, as you called him, Banda, that dried-up little don—especially in light of his personal life."

"He's a don?" Paul asked.

"Fellow of King's," I said.

"Oh well, then," Peter said, "if he's a King's man he must be all right."

"Very much so, most readers think," I said. "Of course, he's also a homosexual."

Both Finchleys looked into the middle distance.

"I think that's why he tries so hard to give ultimate wisdom to a woman," Premadasa said.

"I'm not so sure," Banda broke in. "In spite of his skill, he rewards one at times with touches of unconscious humor. Mr. Wilcox's wooing of Margaret Schlegel strikes that note, at least for me."

"And for me," I said.

"They aren't talking about the *Passage* now, but an

earlier novel, *Howards End*," Premadasa said to the Finchleys.

As he spoke I looked back over our day, and it, together with our present exchange, impressed me as an extension of the *Passage*. Not quite as polished or balanced or comprehensive, but it was all there. Banda and Premadasa and I came close to signaling one another as we baited the Finchleys, throwing out remarks like mine on King's, sure to get a response—a gentle baiting; for Singhalese manners required that much from them as hosts, just as Chinese manners required it from me as guest.

We went on to cognac in snifters, leaning back, five young men pretty much at their ease, three of them slightly, but ever so slightly, enjoying themselves at the unwitting expense of the other two.

We heard the fifteen-minute blast from our liner. "What a pity we can't continue until the dawn," Premadasa said.

"It is," I said as we rose. "But even comedy must end."

"And a number of other things," Banda replied, lightly enough.

Walking along the quay, I felt the empire firm under my feet, but I understood what he meant.

"It may take a long time," I said.

He shrugged. "Who can say? That's the Chinese in you—centuries and all that, and it is a little Indian too. But here on our island, after the Portuguese, the Dutch, there's a difference of perception, I think."

"Anyway," I said, as the five of us stood in a loose circle near the foot of the gangplank, "this postultimate chapter, if you'll allow the word, must end, I'm afraid."

Both Banda and Premadasa smiled at me.

Peter turned back into the ship's doctor, holding out his hand formally and thanking them both for the day before he turned and started up to the deck. Paul echoed his brother. I felt unsure of what to do, but Banda solved my problem by putting his arms around me in a light embrace that I returned. Premadasa and I exchanged the same kind of salute, one that I felt enormously flattered by. Over his shoulder I saw the Finchleys leaning on the rail, watching us.

"I think *he* knew and still knows," Banda said.

"It's not impossible," I answered. A gong sounded and I said a quick goodbye before starting up myself. Then the gangplank came down, we waved, and two tugs moved our ship into the channel. Banda and Premadasa gave us a final flourish as the ship came around, leaving them out of sight.

"How about a nightcap on me?" Peter asked as we went in. "And by the way, John, what on earth were you and my friends doing down there?"

"Just saying an amiable goodbye," I said. "Why?"

"It isn't for me to advise you," he said, "but you are, after all, an American. You mustn't try anything like that in Oxford. It might be misunderstood."

"I'll watch myself," I said. We had reached the first-class bar, and once again we became two young Englishmen with a young American who had been born in Shanghai. As I downed my vodka I thought of it as a full stop at the end of our Forsterian postscript.

Voting Your Own Mind

EACH TIME A PRESIDENTIAL ELEC-
tion comes around I look at the polls, con-
sult the shreds of my conscience, review my
political heritage, and stagger off, sample
ballot (never quite to be followed) in hand,
and pull the curtain of the booth.

Father came from a traditionally conservative Republican
family. Born in what is now a part of Pittsburgh, he spoke, as
had his own father, what used to be called "Philadelphia
English." My Grandfather Espey—a high-school principal
and superintendent—had been a fanatic precisionist in mat-
ters of pronunciation. Even my own father smiled when he

would correct me on some point and go on to say that *his*
father had frequently rebuked him for failing to make precise
distinctions in pronouncing what Grandfather insisted were
three quite different-sounding words: *to, too,* and *two.* I have
always fumbled phonetic systems, so I am only approximat-
ing what Father used to tell me when he said that Grand-
father maintained that one should say *tö* for *to, tōō* for *too,*
and *tŭōō* for *two.*

Father himself held out for a number of distinctions and
never surrendered to Mother's standard Middle-American
pronunciation of words like *dog* and *orange.* Oddly enough,
one thing his otherwise acute ear could not detect was his
own way of saying *don't* and *won't,* which he always pro-
nounced—and to hell with phonetics—*dunt* and *wunt.*

Mother, who came from a mixed New England, Mary-
land, and Middle Western inheritance, sometimes teased him
about this, saying "It's quite all right, Morton, if you wish to
say 'It was his wont to persist in his father's speech,' and
pronounce *wont wunt,* because that's correct; but I can't
understand why you say *dunt* and *wunt* for *don't* and *won't.*
It must have something to do with Pennsylvania Dutch."

Father would put his head back and look down his slightly
crooked nose scornfully. "I could never say *dawg* or *awrange,*
as you do, and I couldn't possibly have been influenced by
Pennsylvania Dutch—it's, as you well know, from another
part of the state, rural and primitive. I *dunt* want to go
through this again, especially in front of the children."

Up to a point, Father enjoyed being teased by Mother, and
after one of these exchanges he would smile, my sister and I
would usually manage to get an extra chocolate if it took
place during afternoon tea, and Mother would diplomati-

cally move on to whatever topic of the day presented itself.

Mother herself brought more than just *dawg* and *awrange* from the Middle West. Precisely what impulse carried her to the University of Wisconsin from a family that married off its daughters early or sent them to finishing school, I can't say. But after four years at Madison, Mother returned to her northern Iowa home town in the summer of 1903 with both a bachelor's degree and a firm belief in that native grassroots radicalism that I have never been able to explain clearly to my Oriental or Continental or British friends. It allowed her to remain "a lady," but when John D. Rockefeller got off the train on one Middle Western visit, in order to endow some institution with a lot of his dimes, it also allowed her to rejoice in the chant of "Oily, Oily, Oily, John D. Almighty!" that greeted him—something that Father preferred she not mention.

Mother kept up an interest in public events. She brought my sister and me to America in 1921, a year ahead of Father's furlough, to see what could be done for our crooked teeth and my asthma. We spent the winter in Des Moines, and though she held a low opinion of President Harding and his cabinet, she felt her children should learn as much about American life as they could.

How my sister got out of it, I don't know—she has always been cleverer than I—but one gelid night Mother and I sat in the gallery of the Des Moines Armory and listened to Vice-President Calvin Coolidge speak on—surely not foreign policy—but possibly the fiscal economy. Mother was right. How many persons, after all, can claim to have heard Silent Cal deliver a full-length, high, nasal, whining address? I remember everything except what he said—my freezing feet,

the unpadded seat, the endless shivering streetcar rides there
and back.

Before this, during the election campaign of 1920, one of
the mission bachelors in Shanghai who was, I realize now, in
love with Mother in a safely unmarried way, rallied her at tea
one afternoon after she had been talking about her Wisconsin
days, her interest in the single tax, agrarian reform, and the
LaFollette brand of liberalism.

"If you're that interested," he said, "what do you think of
the presidential hopefuls?"

Mother had to concede that she couldn't name the Demo-
cratic candidate.

"It's Harding against Cox."

"I can't believe either of them would be as good for the
country as someone like Norman Thomas," Mother de-
clared.

"Norman Thomas!" her non-suitor exclaimed. "What
would you know — I mean, he's in a sense — well, a
Socialist!"

"That has always been my understanding," Mother said,
pouring him another cup of tea. "You like two lumps in this
India stuff, Sidney, don't you?"

"Yes, thank you," he said, shaken.

"Now, about this man Cox . . . " Mother began.

Living the greater part of their lives in China, neither
Mother nor Father could cast a vote in a presidential election
until the Roosevelt-Willkie contest of 1940. By then they had
retired to Pasadena, where they met my wife for the first
time. Her grandfather had been a Presbyterian missionary in
Africa and then, when *his* wife refused to rear a family there,
he became what was called a "home missionary" to the

Mormons, eventually establishing the Presbyterian church of Brigham City.

My mother-in-law, daughter of the missionary to the Latter-day Saints, had begun to backslide well ahead of me. She could bend her elbow, but she couldn't stop. Her feeling about the state of the nation in 1940 was usually pronounced late in the evening with, "I can't understand why Mr. Hoover didn't offer himself to the electorate again. It would have solved everything—don't you agree?" I had no answer except tilting the bottle and pouring each of us another.

Long before election day I came to dread every ring of the telephone. My mother-in-law called repeatedly, sober or not, urging us to save the true America, making remarks like, "Since Mr. Hoover isn't a candidate, we must support Mr. Willkie. I know he has some wild ideas, but when you think of that awful man in the White House and his gabby wife— you do understand?"

When Mother called she would say, "I don't want to influence you, but as you know, I took my degree at Madison . . . "

"Yes, Mother," I would answer, "and though you know Norman Thomas can't be elected, you ought to get great satisfaction out of voting for him. It isn't all that crucial, anyway. Roosevelt is a walk-in in California, and nationally he'll be re-elected."

"So are you voting for him?"

"Not necessarily. Why *not* push to the left? The notion that Franklin Delano Roosevelt is part of the real left is one of the great comic inventions of the age."

"I'm not sure your father would agree."

"Fathers knows *nothing*—he isn't there is he?—but *nothing* about the American political scene."

"You are the one saying that, John."

"I am," I would say. "Father is a hereditary Republican, you are a grassroots American radical with some respect for Wilsonian democracy, and I have married into a family that believes Herbert Hoover is a candidate for the Trinity, were such a thing mathematically possible."

"Is there any way you can keep that woman—I mean, your mother-in-law is charming in her way, but when she begins to tell your father how to vote in a slurred voice . . . "

"I can't do a thing. And I'm not even sure how her daughter is going to vote."

"How odd!"

"Surely no odder than your and Father's apparent indecision," I answered the first time around.

"You're quite right," Mother said. "Your father is just pulling into the driveway, so I'll hang up."

It took Father two or three calls before he put the question of how I planned to vote directly to me.

"In some ways it doesn't matter," I said, "because Roosevelt, in spite of the third-term issue and all the other red herrings, is going to carry California and the nation. Still, even though I'm a registered Democrat . . . "

"*You* are a registered *Democrat*, John?"

"Yes, but . . . "

"You might at least have done it by way of 'Decline to State' if you're going over completely to your mother's side."

"Mother claims she's a grassroots American radical," I said. "That is not to be a Democrat. For the first time in her

life she can vote for Norman Thomas, and that should make her happy."

After a minimum of polite comments on the weather the phone went down.

The day after Wendell Willkie took the air with his first nationwide broadcast, my wife and I were due for dinner in Pasadena. I usually stashed a thermos of martinis and a bottle of vodka in the car because I couldn't bring myself to drink in front of my parents, though they knew we drank. I parked at the street corner a block away and had a couple quickly.

"Don't overdo," my wife said, sipping her single.

"Overdo? I ought to pour down the whole fifth."

"You're a real fool," she said, laughing.

"I know," I said. "I married you for love instead of latching on to a Pasadena fortune, and we are going to hear something tonight you're not prepared for, even if your grandfather *was* a Presbyterian missionary to the Mormons."

"Oh, shut up," she said. "What are you talking about? *Listen!* Don't take another blast straight from the bottle."

"You didn't hear the Willkie speech?"

"No, I had to catch up with the bookkeeping and turned off the radio."

"Then just wait," I said and took another straight shot.

We went into my parents' house, my wife hoping to detect signs of drunkenness in me, I feeling the first ripples of the relaxation I needed.

After the conventional welcomes Father said, "John, did you hear Mr. Willkie's speech yesterday?"

"I did," I said. "You know, Father, I really think it best for a family not to get too emotional over a campaign that

involves as much as this one, especially a family like ours that can't be all that political after those years in China."

I doubt if he heard a word. "But did you really listen?" he asked. "I mean his *speech*. To hear repeatedly in a national broadcast things like *Yournighted Shtatesh uv Amurrica!*"

"After all," I said, "that isn't the worst crime in the world today."

"All I can say is that, despite his upriver New York mannerisms, Mr. Roosevelt speaks literately."

"Yes," I said. "Don't we have some distant Dutchess County cousins?"

"That's quite irrelevant," Father said. "But that incredible *Yournighted Shtatesh uv Amurrica!*"

"Please don't work yourself up, Morton," Mother said. "Everyone should, after all, vote his or her own mind."

"I intend to," Father declared.

"And I," my wife said.

"Me too, in a way," I offered as we went in to dinner.

"Your mother will certainly vote *her* mind," Father said to my wife after he had pronounced a blessing.

"She probably will," my wife said mildly. When we had first met in college she had been a conventional Republican. I had become a New Dealing Democrat and used to say that my mother was a Socialist. In the circles we moved in no one took this as anything but a joke, so I gave up trying to explain.

Election day turned rainy. My wife and I went to work early, stopping off at the polls. She drove me to Occidental, where I taught, and continued downtown with the car. Neither of us had mentioned the ballot.

We picked up my mother-in-law on the way to dinner in

Pasadena the next night. I offered her a cocktail when we parked. She asked from the back seat, "Are you under the impression that I drink?"

"There have been times when I have been," I said.

Then I understood that she was already well ahead of me, because she brought out, "I'm afraid you have forgotten that my father, a graduate of Princeton Seminary, was a Presbyterian missionary to the Mormons."

"Ah, I never forget that, Belle-Mere," I said placatingly, wondering if she had a few shots left in her beaded evening bag. My wife kicked my ankle as I took a straight slug.

We turned the corner and parked in the driveway. Mother and Father greeted us.

"Well," Father said to my mother-in-law, "it was an interesting contest. It was good of you to call us so often to keep us informed and to give us your opinions."

My mother-in-law held steady, but remained untypically silent.

"John kept telling us it was a foregone conclusion in California," Father went on, "and surprisingly, he proved to be correct."

I held my tongue, letting the vodka take over.

"I believe in the secret ballot," Father said, "but if anyone's interested, I voted for Roosevelt—yes, Roosevelt. Imagine having a man in the White House saying *Yournighted Shtatesh uv Amurrica!*"

"I'm not sure pronunciations are all that important," my wife said. "And like you I'm a little surprised that John, having lived in China and abroad so long, was right. Anyway, I voted for Willkie—probably my last Republican vote."

Her mother looked at her with complete affection for the only time that I can remember. "You voted for Willkie, my darling?"

"I voted for Willkie."

Her mother embraced her.

"And you, in your wisdom, voted for Roosevelt," Father said to me.

"Certainly not," I said. "I've tried to tell you all these weeks that a vote for Roosevelt, especially in California, would be a throwaway. I voted for Norman Thomas."

"Norman Thomas!" Mother exclaimed, crossing the room and kissing me full on the lips. As she drew back I knew she had smelled the liquor. "I'm so happy *someone* voted for Norman Thomas."

"Someone?" I asked, surprised.

Mother took another step back and laced her fingers together. "I went into the booth planning to vote for Norman Thomas. I'd always dreamed of voting for Norman Thomas—you know, I went to Madison . . . "

"Yes, Mary, we know," Father said.

Mother laughed. "Thank you for pulling me up. Once in the booth I hesitated. A few days ago I read an article in the *Star-News* saying that if the Prohibition Party couldn't attract a certain percentage of the vote it would be removed from the ballot in California. I remembered my Aunt Janette and my own mother, and how I had had the white ribbon of the W.C.T.U. pinned on me before I was a responsible person. So in their memory, I thought—well, I voted for the Prohibition candidate."

"You remember the name?" I asked.

"Frankly, I don't," she answered.

I felt it discreet to say nothing more, recalling how she had pulled back after kissing me.

"I hope you all realize that this means *I* am the one person present who voted for the winner," Father said.

"You Orientals!" my wife muttered to me under her breath.

"I think everything's ready for dinner," Mother said, turning to my mother-in-law. "Of course there's no need to ask how *you* voted. I can appreciate your devotion to Mr. Hoover. I remember the splendid job he did with the Belgian Relief, and we still know a number of persons who were acquainted with the Hoovers while he was making his fortune in China."

"In *China?*"

"Certainly," Mother said. "Everyone agrees that Lou and Herbert Hoover were charming as individuals, even if he was a trifle stiff socially. But if you want a good example of imperial exploitation . . . "

"Ah well, Mary," Father cut in, "we needn't go into that after all these years." We were seated by now and he turned to my mother-in-law, saying, "You did, of course, vote for Willkie?"

Her voice still under control, if a bit slurred, she said, "You know I live up in La Canada, and it was raining. Since everybody is speaking the truth, and my father, the Reverend Dr. Samuel Lovejoy Gillespie, founded the Presbyterian church in Brigham City, I just didn't think it worthwhile to risk getting soaked and catching my death of cold."

After some seconds of dazed silence Father looked at me and said haltingly, "I know you dislike giving the blessing, John—I respect your feeling—but perhaps for tonight . . . "

"Of course, Father," I said as my wife and Mother exchanged glances. Father glared at the dining room's panels. My mother-in-law's eyes began to go out of focus.

Years before, Mother had made up a couple of simple blessings for my sister and me to use when called upon, and I automatically recited:

> For food and clothing, home and friends
> We thank Thee, Heavenly Father. Amen.

"I appreciate that, John," Father said, coming out of his trance. "I'm happy you remember it. But you know, Mary, that isn't a true rhyme."

"Of course it isn't," Mother came back. "That's part of the fun of it."

"The *fun* of it?" Father asked.

"Yes, the fun of it. Somehow it all fits in with our votes—or non-votes—and the whole American system."

"You dunt say so?" Father remarked, beginning to carve the standing roast.

"Oh, *dunt* I?" Mother answered.

Strong Language

L IKE MOST PROTESTANT MEN OF God of his generation, my father used a large, but at the same time severely restricted, vocabulary in his speech. His strongest expression of skepticism, as I have already indicated, was usually "Indeed?"—almost tantamount to calling one a liar—and his limit of disgust with himself or anyone else was usually "Shucks!" I doubt that he had any notion of what "Shucks!" came from or sounded like. This surprised me, because at home even "Dear me!"—a clear echo of *Deus Meus!* and consequently a diminished form of swearing—was frowned on. When "Cheese and Crack-

ers!" became a favored expletive at the Shanghai American School I foolishly tried using it at home. Father said, "Surely you understand, John, what that is a debasement of?"

I had to say, "'Yes, Father," knowing that I would never again use it in his presence.

The other side of this was that both Father and Mother enjoyed lively language. As missionaries in the native district of Shanghai, they picked up colorful and vigorous phrases on the street that they couldn't always understand, or sometimes misinterpreted.

Father approached anything he wasn't certain of warily. In his earliest days in the mission he had used some overheard phrases in his chapel talks that approached obscenities. So whenever he heard an expression that appealed to him but couldn't find in his Chinese dictionaries or phrase books, he went through a series of maneuvers. He would approach one of his more intimate Chinese friends, saying how ashamed he was of his ignorance of the language even after all these years in the land to which he had dedicated his life. He would then repeat what he *thought* he had overheard on the street, and would thus learn if it was respectable or not.

Mother, on the other hand, though her knowledge of written characters remained elementary, rarely censored herself and would use phrases in class that enchanted her students. One of these was roughly the equivalent of "Give the mare a blast in the ass," which she understood to mean "Pat the horse's rump," a term of encouragement. Soon word reached her that this was considered a bit too racy for the classroom. Even then, she laughed about it at home and told Father and me, though she did not use the paraphrase I have given.

"If you'd asked *me,* I could have told you," I said without thinking. "Not that my Chinese is all that good, but I do have the tones even if I can't read much. I've picked up a lot of that kind of thing from being brought up here instead of the Settlement or Frenchtown like the Myers kids. They really haven't a clue to what they're hearing sometimes."

"You *dunt* say?" Father brought out, but I failed to catch this signal of alarm. It wasn't often in those days that I could teach my parents anything and I rashly went on, "Everyone knows about being called a 'foreign devil' but I *was* surprised the first time Henry Myers and I got into a tangle during lunch hour at the old school up on North Szechuan Road. We were bargaining with a street-vendor, and I guess we pushed him too far—we were buying Sen-Sen—and he said, well, you know . . . " and I stopped, appalled by my stupidity, because I had been on the point of saying the Chinese equivalent of "Screw your own mother!"

My luck held, because Father demanded, "What did you want Sen-Sen for?"

"Oh, no reason at all," I said. "I like violet-flavored Sen-Sen and Henry likes cinnamon. Sometimes we just pick up a couple of packs as a kind of lunch dessert."

"Most persons use Sen-Sen to cover the smell of liquor or tobacco on their breath," Father said sternly.

"I know that," I said, "but it's cheap, it has a nice taste, and so . . . "

"You like *violet*-flavored Sen-Sen?"

Mother had been looking at me quizzically during this exchange and she broke in with, "I don't suppose anyone completely masters a language learned after adolescence, but

what if one makes a mistake or two? Isn't it better to try speaking idiomatically than formally all the time?"

I saw what she was up to, because we both knew that Father felt she was negligent when it came to learning characters and she really could read very little Chinese. I sidled out of the room, suspecting that Mother knew perfectly well what had stopped me in my story.

This interest in language continued with Father after he had retired from the mission field and my parents had bought a house in Pasadena. He used to approach me on one of three fronts when my wife and I went there for our duty-bound weekly dinner.

Father, without ever having queried me on the subject, was sure that, as an English teacher, I believed the King James Bible a monument of English prose that should satisfy all and never be tampered with. That it was a monument, I assured him several times, trying to add that even in 1611 its prose reflected idioms and rhetorical patterns already rather old-fashioned. He never listened to me and every third week or so he would come up with something like, "Aha, John, I know you disapprove of changing anything in that sacred Stuart text, but can you honestly think anyone today, even yourself, can make sense out of 'Only he who now letteth will let, until he be taken out of the way'?"

And I would say, "Well, probably not just *anyone*, Father, but certainly *I* understand it—*Second Thessalonians*, isn't it?—not only because 'without let or hindrance' remains a part of legal language but also because I had a wonderful tennis teacher, so I know what a *let* ball means, even if Jack Kramer and other sports announcers say something about its coming from 'Let's have another serve!'"

"You don't mean it!" he would say, and I would be safely off that particular hook and wouldn't have to try once more to say that I thought every generation bore its own responsibility for translating the classics and that I approved of his spirit, if not his style, whenever he preached or taught in Sunday School and went back to Hebrew or Aramaic or Koine Greek for his own personal translations.

If he didn't confront me with obscure passages from King James—I don't know how many times he asked me to define "crisping-pins"—he would ask me about alcohol, because he knew that I drank, though I would never drink in front of him.

His third approach was to quote some bit of swearing or vulgarity that he had overheard—even in Pasadena—and question me about it. He might say, "How, as an English teacher would you put 'Stuff it!' into acceptable form, and precisely what does it mean?" And I would do what I could to deal with *that*.

Long before the fall of Shanghai to the Japanese, Father grew increasingly angered by the folly of America's selling scrap metal to Japan and decided to do something about it. He held a poor view of poetry and fiction, but one evening after dinner he said to me, "I've been thinking about this, and I've decided that what is called for is a great piece of literature, possibly a not very long poem, that will expose the idiocy of this policy. Your mother still reads poetry and I know you teach courses in it. I've recalled the effect of Thomas Hood's 'The Song of the Shirt' on England's treatment of laborers and piece-work."

"Ah, yes," I said, afraid of what was coming. Six months before this, Father had told me that he thought the words of

many standard hymns no longer reached young people. I couldn't disagree with him, but I had to tell him as tactfully as I could that the doggerel he had put together for certain tunes was no improvement. I did my best to polish his lines. His pupils in the Sunday School class he taught at the Westminster Presbyterian Church sang them to his gratification but without, I suspected, any difference in their conduct.

I am an only son, long lapsed from the Presbyterian faith in which I was reared, though retaining from my Chinese boyhood some over- and under-tones of the Confucian tradition. Not a single verse of Father's scrap-iron equivalent of "The Song of the Shirt" survives. That this is true is an essential part of my filial duty to his memory. I slaved and slaved over his effort, but in the end I had to say, "Really, Father, this is pure Savoyard—you know what I mean, Gilbert and Sullivan."

"How generous of you to say so," he said. Mother left the room as I began trying to explain.

By this time we had almost nothing in common to discuss seriously. I knew how disappointed he was in my failure to go to seminary, to follow in his footsteps, to answer what he was sure was my "calling." I had long since given up trying to explain my private convictions to him, but he persisted at intervals in approaching the subject.

Whenever Father raised any of these issues Mother was afraid that I would finally be provoked into speaking out, into saying flatly that he and I looked at life so differently that there was no point in discussing our beliefs, but I managed to temporize and evade, probably as much out of cowardice as from love.

Yet he remained eager to get my advice, almost to trust my

ear, when it came to language. He enjoyed tremendously reporting conversations he had overheard on the street, exchanges that allowed him to say, "And then the older man said to the younger, 'Go bugger yourself!' which really surprised me down on Colorado Street, and the younger man said—I believe your mother is in the garden—'Try it yourself!' "

"You don't say?" I would ask in mock solemnity.

"I do indeed. I assume you understand the meaning of those words?"

"I do. After all, you sent me to some of the best schools in the world."

On such occasions he might look mildly annoyed, but would go on to whatever he had next in hand. One evening he was working on an imperative construction and he asked, "Which do you think is more forceful, a simple imperative like 'Go to the street which is called Straight' or 'You go to the street that is called Straight'?"

"I'm not sure," I said. "Of course that's from *Acts*, isn't it, and everyone's ear is so conditioned by the King James that it's hard to say."

I could see he was both pleased and annoyed that I could in effect give him chapter and verse. "Maybe we should try something more ordinary," I said. "I suppose the commonest . . ."

"Most common, I think . . . "

" . . . the commonest imperative idiom in use today would be something like 'Go to hell!' or 'You go to hell!'"

"That's ingenious," he said. He had never in his life been able to tell anyone to go to hell. Here was his chance. "Go to hell!" he said, and then, "You go to hell!"

"Yes," I said, "but if you put the stress on *you*, you know, and say '*You* go to hell!' that's a third way. Or if you shift to *hell* or *Go* in the shorter construction."

"That's right," he said, "that's very observant of you." And he tried out "*You* go to hell! You go to *hell!* Go to *hell!* Go to hell!"

I responded with, "Yes, but even then, you've got the chance of absolutely equal stress, if you know what I mean— *Go to hell!* or *You go to hell!*—each is different."

He nodded enthusiastically and went through both constructions.

Our voices had risen. Father's face, and I'm sure my own, grew flushed as we tried out all the variations.

"Sometimes it's more effective to underplay it," I said, and with a minimum of emphasis, but still with clear enunciation, I dragged out every vowel of "You go to hell!"

"Ah, yes," Father said and echoed me, but pulled out the vowels even longer than I had. "That's devastating!"

We sat on opposite sides of the table with his papers spread out between us. I saw the swinging door to the pantry being pushed open slowly. There stood Mother, her face strained, her eyes filled with tears.

I jumped up and said, "Oh, Mother, I should have come to help you, but Father had this fascinating problem in translation that we got completely wrapped up in. I mean, do you think there's a great deal of difference between saying, 'Go to hell' and 'You go to hell'?"

"Do you mean to say that that's what the two of you have been shouting about?"

"Yes," Father said, "it's really an interesting question. As John pointed out, you can stress one word or another

word or all or none and get quite a different result each time."

"Truly?"

"Yes, indeed."

"Well, it isn't a command I've ever used," Mother said, "but I don't suppose it's really either quite swearing or blasphemy."

"Probably not," Father said innocently, but I suspected what was coming.

"Well then, all I can say is that the two of *you* can go to hell!" Mother declared.

"Mary!" Father exclaimed.

Mother dissolved into laughter and finally had to use her handkerchief. I began to laugh too, but I knew we had to be careful. Father looked at Mother and then at me and said grudgingly, "Yes, I suppose the situation has its elements of humor."

"Elements of humor!" Mother gasped.

"Surely that's why you're laughing?"

"It is, indeed," Mother said, drying her eyes.

I had remained standing. Mother put one hand on Father's shoulder and with the other she reached across the table and tweaked my left earlobe with all the pressure she could summon between thumb and forefinger.

Strong Drink

ONE OF THE FIRST BIBLE VERSES I had to memorize after learning the Ten Commandments, the Lord's Prayer, and the Twenty-Third Psalm was *Proverbs* 20:1: "Wine is a mocker, strong drink is raging: and whosoever is deceived thereby is not wise." This was a favorite among Prohibitionists of all creeds during the 1920's and I must have heard it quoted dozens of times during my boyhood.

Although Father was in full accord with this statement, I was astonished early in my teens to have him tell me that he was held back from indulging in alcohol not only because of

the Scriptures but also because he felt certain that he himself could not remain temperate—a word he insisted on using accurately—but would riot out of control on the slightest provocation. With the bland condescension of youth I used to entertain myself trying to picture Father going berserk after downing a couple of shots of whisky or a glass or two of wine.

Not that I was much more sophisticated than Father in such matters. It would be a number of years before I put down any appreciable quantity of bootleg liquor while going to college. But as a slightly precocious reader of the period's fiction, I felt myself qualified to judge a thing or two, and at the Shanghai American School one of my classmates, the son of a Swiss businessman, described knowingly the effects of sherry before, champagne with, and port or whisky after his dinners at home.

In the aseptic tradition of the day, Welch's grape juice served as the Blood of Christ in our Presbyterian communion services. I became a reluctant communicant myself at the age of thirteen, when the condition of my father, a recurrent victim of what was then called "religious melancholia," was used to exert pressure on me to overcome my skepticism. This had survived even a course of preparation by a Low-Church Anglican clergyman who gave instruction at the Kuling American School—where I was a boarder—to children of all brands of Protestantism. I grew sullen under this pressure, but I still had enough curiosity about the ceremony to wonder if anything would really happen to me, and if the grape juice would taste any different from the iced Welch's that we drank during hot summer afternoons. I was not really surprised that it didn't, though it was not chilled.

Some of the older boys at Kuling used to buy bottles of Chinese rice wine and hide them in stone walls or under the porches of summer cottages. It was not so much timidity that kept me out of this as my having a more exciting and legal access to alcohol, which I never thought of as "drinking," through my being asthmatic and a frequent patient in the school infirmary. The resident nurse, a woman of understanding who felt that the school doctor's treatment of my case lacked imagination, on her own authority used to slip me a good dose of cognac on occasion just before lights-out. This was purely medicinal and it never occurred to me to mention her treatment when I wrote home or went back to Shanghai during vacations.

The Kuling American School closed in 1927 because of Chiang Kai-shek's northward march, so I became a boarder at the Shanghai American School, free to go home over weekends and thus enjoy the best of being a boarder and a day pupil. One of the families living in the mission, the Corbetts, indulged in a rather evangelical southern turn of faith, though they masqueraded as controlled Presbyterians, and in the earlier years of their marriage they came to my parents for advice on a number of matters.

The Corbetts' situation was made no easier by their having Mrs. Corbett's elderly and opinionated mother, Mrs. Lake, living with them—something that neither of my parents felt was helping in an already difficult situation. Mrs. Corbett had spent her girlhood in an upcountry mission station and had then attended a southern college for women in America. Mr. Corbett was a teetotaling Belfast Protestant. Many felt that height provided the real base for their marriage. Mrs. Corbett stood very tall for that generation of woman and

Mr. Corbett stood even taller than she. In public they made a striking couple, but in private things apparently did not go too smoothly.

My knowledge of the situation was slight, acquired through overhearing an occasional remark at home. When Mrs. Corbett had left the house one afternoon I heard Mother say, "But how could anyone growing up in China be *that* ignorant?" Father's reply was cut off when he caught sight of me coming downstairs. On another occasion, after Mr. Corbett had returned home late in the evening following a long closeting with Father, we were surprised by the arrival of the Corbetts' houseboy carrying their black leather chitbook. It contained a hastily written note from Mrs. Lake that read in its entirety: "My dear Mr. Espey: I hope that you do not think that when you die all wisdom will die with you. Sincerely yours, Cornelia Lake (Mrs. R.T.)." Father shrugged and told the houseboy not to wait for an answer.

The Corbett-Lake household held far more severe opinions than my parents on the evils of drink. Mr. Corbett more than once assured me that the reason so many biblical figures had drunk wine or worse was that the water of those times and places was as unsafe to drink in its natural state as the water of China in our day. This explained the popularity of tea in China, because tea required boiling water. In a kind of perverse logic, Mr. Corbett even explained to me once, when I had foolishly expressed doubt, that the first miracle, the turning of water into wine at the marriage at Cana, supported this view—that the miracle had been performed to prevent the guests from drinking water and thus risking infection and possible death. By then I was old enough not to prolong the argument. When I referred to it at dinner that

night both Mother and Father smiled. I said it was hard to shake someone like Mr. Corbett on anything.

Mother said, "Well, we seem to have taught them *one* thing." She laughed and Father looked at her, shaking his head.

"Mr. Corbett sounded ridiculous," I persisted, wondering why they were acting this way.

Disregarding Father, Mother said to me, "You'll learn about it sooner or later, and since you've been brought up in China, anyway, it shouldn't surprise you to know that for a long time the Corbetts have wanted a child and now they are going to have one."

"Oh," I said. All the comments I had overheard arranged themselves and I found myself both blushing and looking at my parents with new respect.

The cook came in with the Corbetts' chit-book. This time the note came from Mrs. Corbett, addressed to Mother, inviting the three of us to come over and have dessert with them.

"I suppose this is a sort of celebration," Mother said as she began to write her acceptance. Father broke in, saying, "I shan't be able to go, my dear. You know I have that board meeting at the school."

"I'm afraid I'd forgotten," Mother said as she added a postscript.

Fifteen minutes later Mother and I went through the side gate into the Chinese cemetery and walked through it to the Corbetts' house beyond. The Corbetts had dined and awaited us in an upstairs sitting room they used for Mrs. Lake's convenience because she had grown enormously heavy. "I'm cursed with these delicate Southern ankles," she often

declared. They gave her problems moving even with a cane in each hand, so she spent most of her time shuffling between this sitting room and her bedroom. I could believe that her presence would be inhibiting in many ways.

Mrs. Lake showed no sadness over Father's absence.

Mrs. Corbett said, "We're glad someone could come because we have a surprise for you." I supposed I knew what the surprise was going to be, but I didn't. "Yes," Mrs. Corbett went on, "last week when I sent my order in to the compradore I wanted some peppermint flavoring, and they sent me a big bottle of a different kind. It tastes so good that we've been using it to make sundaes."

Their tableboy came in with the ice cream and a tall bottle half filled with green liquid.

"Ah!" Mother said, her eyes widening in her private signal of inner comedy.

Mrs. Corbett poured generously from the bottle over our servings of vanilla ice cream.

"It has an unusual flavor," Mrs. Lake said.

"Yes, it has," Mother said.

I thought so too, and I also knew that though this wasn't a patch on the Kuling cognac, it bore a distant relationship to it.

Everyone had seconds and we picked our way delicately through some knowing references to the future. Mother sounded especially animated, and even Mrs. Lake found a few things to smile upon.

"Well," Mother said as we walked home, "it's probably a good thing your father couldn't come. I don't know what he'd have said to being served a *crème de menthe* sundae. On the whole, it's probably best to say nothing. Not that the servants won't already know everything about it."

Later that spring I spent Easter in Ningpo with family friends. On Sunday all the Protestants attended a service at the Anglican church, which was so very low that the rector served communicants of all sects. I enjoyed the ceremony of kneeling at the rail, and having watched those ahead of me carefully, I took a full gulp from the proffered chalice. What I held in my mouth was not Welch's grape juice. After the Kuling cognac and the Corbetts' *crème de menthe* I swallowed without hesitation. Like Mother, I wondered about Father's reaction and said nothing when I returned to Shanghai.

The notion of Father in similar circumstances was itself ridiculous. His tastes and beliefs were so well-known that even when he attended feasts given by his non-Christian Chinese friends a special servant stood behind his chair to fill his winecup with Welch's as he drank toasts along with everyone else. This in the end proved his undoing; for one of his more casual and recent Chinese acquaintances invited him to a feast and assured him that he had ordered the precise wine he had seen Father drinking two weeks before at old Mr. Tsiang's feast.

Assuming that he was once again being provided with Welch's, Father tossed off his full cup at the first toast, as was his custom, and even though he had not had my advantages, he too knew what he had in his mouth. Calvinism and good manners met there and good manners won—at least for the moment. Father refused his instant refill politely, much to the distress of his host. As the feast continued, Calvinism began to edge back in, and by the time Father left, excusing himself as early as he felt he could without offense, he was close to genuine depression.

144

Strong Drink

I was not at home, and I heard of this only later, but Father had the good sense to confide in Mother, who assured him, while she stifled her laughter, that he had not sinned, that it was just one small cup, that—well, I don't know what else, because for a long time I couldn't understand Father's diminished mood except to feel a dread of what might come.

In the end I learned about it because it was a good story and Mother couldn't tell it to anyone else, my sister having gone to college in America the year before. It added to the mother-son conspiracy that had grown up between us, protecting Father, but we never mentioned it in the family and I dared touch on it only years later. My parents had retired and bought a house in Pasadena, where my wife and I, and later our daughters with us, visited them regularly. By this time Father knew that I drank, but I never drank in front of him—theoretically out of filial respect, but actually out of cowardice. He got a certain pleasure out of asking me questions like, "Now, just what does *dry* mean in connection with wine? I was reading a book the other . . . " and I would do my best to answer. Or he would say, "Those liquor ads that Harry Luce's boy allows in that magazine of his are really gaudy, aren't they?" and I would say, "Ah, yes," and he would come up with something like, "Could you explain just what *proof* means?"

Smiling, I would say, "Well, Father, you know perfectly well that after the printers set up type they pull . . . "

"Oh no, no," he would say, smiling back. "I mean 80-proof or 100-proof," and I would do my best to explain *that*.

What use he made of all this I wasn't sure. I found it hard to picture him with his Presbyterian friends saying, "My son tells me that 80-proof whisky means . . . " No, I think he simply wanted me to know that he knew.

Encouraged by this notion, I risked saying one night when we were alone in the sitting room after dinner, "You know, Father, we've never said anything about that feast of Mr. Chao's you went to years ago, thinking you were going to have Welch's the way you always had it at old Mr. Tsiang's."

"No, we haven't," he said, "but I'm sure you know all about it from your mother."

"Oh, I wouldn't say *all,*" I said.

"Well, I drank just that one cup," he said defensively, "and it really was, I think, the only thing I could do. Sheer manners required it."

"I agree entirely," I said. "You had no choice. But I don't mean that. I just wondered how you felt afterwards—physically, that is."

He paused, and I asked myself, a worried adolescent at forty, if I had stupidly broken the bonds that still held us, bonds that we had both taken great pains to preserve. They prevented us from talking about anything intimate or important. We kept to banalities and an occasional pat on the elbow or shoulder.

But now I saw he was smiling. He tossed his head back in what he must have thought a rakehell attitude, sensing all that old riot and loose living he had avoided, and he said, "Well, it was warming, John, warming."

I laughed and it should all end there, but it didn't because some years later my parents gave up their Pasadena house and moved into an endowed home for retired missionaries—exclusively Presbyterian, of course. When Mother entered the infirmary, wasting in a long death, Father sagged into his final depression, in the first stages of which he could not endure to be alone or with anyone but his own children. So

my sister and I arranged our lives on a schedule that gave me long weekends with Father and her the center of the week until, after three months, we could move him into the kind of impersonal infirmary care that he could tolerate.

For those months I found it impossible to do without some support as I drove him to see Mother after lunch each noon and sat up with him at night until he dozed off from exhaustion and a sedative. During the intervening years I myself had known depression and learned the difficulties of being temperate, though my indulgences hardly fit the kind of wild riot that Father had imagined. We remained mannerly still, but part of my manners depended on the fifth of 100-proof vodka I hid under my pillow—my "bolster" as I referred to it to my wife and my sister.

For weeks I thought I was carrying it off, taking a couple of quick slugs before we drove to the infirmary, letting them hit me as we arrived and I turned into a light-hearted fifty-year-old boy, whizzing Mother up and down the corridors in her wheelchair, making her laugh. At night I sat by Father's bed, drinking vodka and milk—"Blue Ruin" I christened it, remembering a passage from Pierce Egan—and we would talk, skirting anything dangerous, tender for each other, waiting for the Santa Fe night freight to whistle as it went by.

I thought I had fooled him, that his still-bright brown eyes had taken my high spirits at noon for pleasure in Mother's company and my bedside glass of milk as a soothing digestive. But one night he asked, "Just what are you drinking there?"

"Milk, Father, milk," I said in panic. I held the glass out toward him, dim in the night-light. "Would you like some? I can bring you a glass if you don't want this." I marveled at my nerve in offering it to him.

"Indeed?" his answer came back. "And what does it do for you?" he asked. I could tell from his voice that the sedative had reached him.

"Well, even though it's cold, Father, I find it warming," I said.

"Warming?" he asked.

"Yes, warming, Father, warming," I said.

The drug was taking him now. He slurred out "Warming?" again and gave one of his rare chuckles. I wondered if he slid off into a vision of uncontrolled revelry as I pulled the blanket up over his chest and then drained my glass. I hoped not, because I knew that if he remembered it on waking he would suffer guilt, and I also knew that he had months of suffering still to endure and that we would never again say anything meaningful to each other.